Twentieth-Century American Drawing: Three Avant-Garde Generations

Twentieth-Century American Drawing: Three Avant-Garde Generations

The Solomon R. Guggenheim Museum, New York

Published by The Solomon R. Guggenheim Foundation,

New York, 1976

ISBN 0-89207-001-3

Library of Congress Card Catalogue Number 75-45506

© The Solomon R. Guggenheim Foundation, 1976

Printed in the United States

Harry N. Abrams Family Collection

Mr. and Mrs. Walter Bareiss

Timothy Baum, New York

John Bedenkapp

Mr. and Mrs. E. A. Bergman

Mr. and Mrs. Michael Blankfort

Mr. and Mrs. Donald Blinken

Mr. and Mrs. Peter M. Brant

Dr. and Mrs. Bernard Brodsky

Doris Bry, New York, for Georgia O'Keeffe

Mr. and Mrs. Leo Castelli

Mr. and Mrs. George K. Conant

Andrew J. Crispo, New York

Dr. and Mrs. Victor D'Arc

Roger Davidson

Mrs. Stuart Davis

Mr. and Mrs. Lee V. Eastman

Dr. and Mrs. Theodore J. Edlich, Jr.

Henry and Maria Feiwel

Helen Frankenthaler

Mr. and Mrs. B. H. Friedman

Jackson Friedman

Mr. and Mrs. Victor W. Ganz

Dr. and Mrs. Martin L. Gecht, Chicago

Baroness Minda de Gunzburg, Paris

Mr. and Mrs. Ben Heller

Kay Hillman

Carroll Janis

Jasper Johns

Ferne Kandel Kolodner

Steingrim Laursen, Copenhagen

Robert Lebel, Paris

Alicia Legg, New York

Roy and Dorothy Lichtenstein

Max Margulis

Mitchell, Hutchins, Inc., New York

Mr. and Mrs. Morton Neumann

Annalee Newman

Patty Oldenburg

Mr. and Mrs. I. David Orr, New York

Vals and Robert G. Osborne

Mr. and Mrs. Stephen D. Paine, Boston

Robert Rauschenberg

Mr. and Mrs. Henry M. Reed

Reis Family Collection

Carl Frederik Reutersward, Lausanne

Esther Robles

Sharon Percy Rockefeller

Mr. Lawrence Rubin

Mr. and Mrs. Sidney Sass

Michael Scharf, New York

Mrs. R. B. Schulhof

June W. Schuster, Pasadena

Allan Stone

Mario Tazzoli

Mr. and Mrs. Burton Tremaine, Meriden, Connecticut

Mr. and Mrs. Kenneth Tyler

Mrs. Lloyd Bruce Wescott

Mr. and Mrs. Bagley Wright

The Art Gallery of Ontario, Toronto

The Art Institute of Chicago

Australian National Gallery, Canberra

The Baltimore Museum of Art

The Brooklyn Museum

The Cleveland Museum of Art

The Columbus (Ohio) Gallery of Fine Arts

Fogg Art Museum, Harvard University, Cambridge, Massachusetts

The Solomon R. Guggenheim Museum, New York

Hirshhorn Museum and Sculpture Garden, Smithsonian Institution, Washington, D.C.

The Metropolitan Museum of Art, New York

The Minneapolis Institute of Arts

Munson-Williams-Proctor Institute, Utica, New York

Museum of Art, Carnegie Institute, Pittsburgh

Museum of Fine Arts, Boston

The Museum of Modern Art, New York

Philadelphia Museum of Art

Seattle Art Museum

Whitney Museum of American Art, New York

Yale University Art Gallery, New Haven

Leo Castelli Gallery, New York

Andrew Crispo Gallery, New York

Terry Dintenfass, Inc., New York

André Emmerich Gallery, New York

Richard L. Feigen, Inc., New York

Fourcade, Droll Inc., New York

Locksley Shea Gallery, Minneapolis

Marlborough Gallery, New York

David McKee Gallery, New York

Valley House Gallery, Dallas

William Zierler Gallery, New York

Drawing exhibitions have occupied an important place at the Guggenheim Museum ever since the Frank Lloyd Wright building opened on Fifth Avenue in 1959. Our interest in this medium was first expressed in two collaborative efforts with the University of Minnesota, the second of which was joined by the Fogg Art Museum. These were exhibitions of nineteenth and twentieth-century master drawings held, respectively, in 1962 and 1963. In a later pairing, current American and European drawings were shown in 1964 and 1965 at the Guggenheim and subsequently toured the country. The exhibition of *Twentieth-Century American Drawing: Three Avant-Garde Generations* presented here thus takes place a decade after the conclusion of the previous sequence. Quite appropriately, in its focus on American art, it inaugurates the Bicentennial Program which will unfold further during this anniversary.

Twentieth-Century American Drawing connects three generations of artists that have, in their respective periods, an avant-garde position in common. Despite obvious stylistic differences, the generation represented here by Dove, Duchamp and Macdonald-Wright, among others, shares certain attitudes with the post-war era of de Kooning, Pollock and Motherwell; and Rauschenberg, Lichtenstein and Warhol, by way of example, in their turn, reveal interesting analogies with both preceding pioneer movements. Parallels and distinctions are underlined by the selected works themselves and are discussed in the catalogue essay which follows. These issues are here given a common denominator — the drawing medium. As in previous instances at the Guggenheim, drawing is defined very broadly to include black and white, and color as well as collage always, however, on a paper support.

Twentieth-Century American Drawing was selected and assembled by Diane Waldman, the Guggenheim's Curator of Exhibitions. Mrs. Waldman has benefited from help and advice both within and outside of the Museum. In her name, I therefore would like to acknowledge valuable aid received from Doris Bry, Joan Washburn, Bernice Rose and the Leo Castelli Gallery. Terry Dintenfass, Kynaston McShine, Andrew Crispo, Xavier Fourcade, Paul Cummings and Theodore Stebbins have also been particularly helpful.

Besides the usual support from virtually every Museum department, Mrs. Waldman was aided during various stages of the exhibition's preparation by Karen Lee and Sabine Rewald, as well as by Carol Fuerstein, who edited the catalogue and worked on the publication's documentation.

The generous lenders to this exhibition are listed separately and share due credit with the New York State Council on the Arts which, through its basic support of the Guggenheim Museum's programs, makes exhibitions of this kind possible.

The wide-ranging Bicentennial celebrations in American art museums can be rendered truly significant if the cultural institutions concerned emerge strengthened by serious concentration upon themes suited to the occasion. In the case of the Guggenheim Museum, the sequence of special exhibitions devoted to twentieth-century American art is presented, in the first instance, for its own sake and with the expectation that it will prove enjoyable and instructive. Beyond this immediate purpose the Bicentennial Program inaugurated by *Twentieth-Century American Drawing* will, we hope, lead to an increased awareness of persisting gaps in the Guggenheim's collection and to efforts aimed at their reduction.

Thomas M. Messer, *Director*
The Solomon R. Guggenheim Museum

Avant-Garde America

Diane Waldman

Drawing has assumed a more diversified and prominent role for the artist now that the theoretical premises of painting and sculpture have been called into question. The very meaning and nature of drawing have changed so much that its definition in Webster's dictionary as the "act, art or technique of representing an object or outlining a figure, plan or sketch by means of outlines" is, to say the very least, obsolete in terms of the avant-garde. Nevertheless, despite the fact that drawing is less strictly defined at present than it has ever been, certain inherent characteristics of the drawing of the past remain valid today. In contrast to the often elaborate processes involved in painting or sculpture, drawing now, as it has traditionally, utilizes the barest essentials for its realization. Because of this simplicity and directness, drawing is still the most intimate record of the artist's imagination. Moreover, despite the radical innovations of the twentieth century, drawing continues to fulfill its two traditional roles, serving as either a finished work or as a preliminary study for a painting or sculpture. In the first instance, the drawing is as complete in itself as a painting or sculpture. As a sketch in preparation for another work, the drawing retains the qualities of direct notation. In schematic drawing, subtle refinements and finish are suspended in favor of the overall concept. Where drawing exists as a separate entity, such considerations become essential to the final effect. In both cases, however, drawing can be diagrammatic and analytical, spontaneous and improvisational.

Drawing has always been extremely adaptable in terms of scale and in aspects of its relationship to painting. Avant-garde artists, like those of the past, have made small drawings for paintings of relatively small scale. Other artists, like Franz Kline or Roy Lichtenstein, have drastically enlarged small sketches into much larger paintings. For some artists, for example Jasper Johns, drawings both precede and evolve from painting. Despite this flexibility, the relationship between painting and drawing has, and continues to be, a symbiotic one.

Drawing has radically influenced both the form and techniques of recent painting. One need only cite the pronounced effect of Cubist collage on painting or note the direct influence of Surrealist automatic drawing,

rather than Surrealist painting, on the work of such leading members of the New York School as Arshile Gorky and Jackson Pollock. Indeed, drawing has not only influenced painting but, in the late 1960's it began to approximate painting in many respects.

The manner and materials of drawing — the placing of marks on paper — had changed very little for centuries until the invention of Cubist collage. The cut edge of collage then replaced the drawn line, and the fragment of a real object became the surrogate for the representation of that object. The realm of drawing subsequently has been expanded to encompass not only pencil, pen, brush, ink, watercolor and collage but any medium the artist deems suitable. Even where the means of drawing remain conventional, there has usually been a change in form from realistic figuration to near or virtual abstraction, whether biomorphic or geometric. With the change in procedure, form and materials changed accordingly, and it is this sequence that is recorded by the avant-garde of the twentieth century.

The first wave of the American avant-garde, shaped by European modernism as proclaimed by the International Exhibition of Modern Art (or the Armory Show as it is more familiarly known) at the Sixty-ninth Regiment Armory in New York in 1913, discarded with seeming finality the tendencies then prevalent in this country's art. Rejecting both native American realism and the sophisticated but equally *retardataire* neo-classicism of the National Academy, they chose to embrace a succession of *isms,* foremost among them Impressionism, Expressionism, Cubism, Futurism and the pioneering work of Cézanne, Picasso, Delaunay, Matisse and Kandinsky. Their all-consuming enthusiasm paralleled the larger experience of America's absorption of seemingly unending waves of immigrants. Although the consequences for both the artists and the country at large proved problematic, the sheer energy involved in this assimilation of the new and the unknown served both in a similarly dynamic way.

The passion for change, which engulfed the art world at the time of the Armory show, had, in fact, begun several years earlier, most notably in the circle of Alfred Stieglitz. Stieglitz, in 1905, opened the Little Gallery of the Photo-Secession at 291 Fifth Avenue, later known as "291," concentrating his initial efforts in the area of photography. By 1908, however, he had enlarged the scope of his gallery to include exhibitions of the leading exponents of advanced European art. With the help of the photographer Edward Steichen, Stieglitz presented, between 1908 and 1911, the first American exhibitions of Rodin, Matisse, Toulouse-Lautrec, Rousseau, Cézanne, Picasso. Stieglitz continued to exhibit European artists after the Armory Show, most notably Picabia, Brancusi and Severini, while at the same time supporting American artists. Among the Americans he exhibited were Marsden Hartley (1909), Alfred Maurer (1909), John Marin (1910), Marius de Zayas (1910), Max Weber (1911), Arthur B. Carles (1912), Arthur Dove (1912), Abraham Walkowitz (1912), Oscar Bluemner (1915) and Georgia O'Keeffe (1916). Stieglitz' presentation of the newest tendencies in art met with little support. To an audience unaccustomed to attacks on social taboos, his championing of the work of Rodin, with its unabashed eroticism, or of Dove and O'Keeffe, with their inherent pantheistic appreciation of nature, eventually cost him both the gallery and his equally avant-garde magazine, *Camera Work.*

Stieglitz' juxtaposition of advanced European and American artists was, for its time, extraordinary, and it forms a curious parallel to developments in American art around the 1950's. Just as the Armory Show of 1913 inspired the earlier Americans, the rush of emigré European masters to the United States at the time of World War II provided the catalyst for the nascent New York School. The correlations between these two events are striking, especially with regard to the relationship between the mature Europeans and the still unformed Americans. In both eras, one movement among the many became paramount: Cubism came to dominate the advanced thinking of the pioneer abstractionists, just as Surrealism prevailed over Neo-Plasticism as a primary influence upon the New York artists. And just as Analytical Cubism eventually proved too rigorous in its formal structure for the Americans, so the later permutations of Surrealism, with their extreme literary symbolism, became unpalatable to the New York School. Moreover, a

characteristic of both generations of avant-garde artists in America is a singular need for the concrete, either in terms of figuration or technique, within abstraction. Thus a reluctance to shed representation entirely characterizes even the most abstract American artist of the early twentieth century, while an insistence upon the materiality of paint and emphasis on process, action and gesture sets the Abstract Expressionists apart from the limited metaphysical poetics of the Surrealists.

The sublimation of representation to abstraction in the early twentieth century brought with it a new awakening to the potential of pure form and color. Painters like Dove and O'Keeffe, on the one hand, and Morgan Russell and Stanton Macdonald-Wright, on the other, exemplify the radical changes of the time. Dove found in nature an equivalent for his inner emotional existence which enabled him to depict in his drawing, assemblages and paintings, an abstract imagery not unlike that of Kandinsky. Kandinsky's *On the Spiritual in Art* reveals a Theosophical premise that was alien to the American Dove; nonetheless, Dove, much like Kandinsky, thought that he could symbolize the forces of nature and convey the impression of sounds, like those of foghorns on Long Island Sound, by means of concrete imagery. O'Keeffe experimented with images ranging from those expressing the erotic potential of plant forms to astute renditions of urban and rural phenomena. The contradiction between representation and pure abstraction in her forms is always held in a sensitive equilibrium. Both Macdonald-Wright and Russell, who first met in Paris in 1911, proposed a far more radical, if short-lived, departure from representation in the form of color abstraction, which Russell named Synchromism, meaning "with color."

Synchromism coincided with a similar style, Orphism, spearheaded in Paris by Delaunay. Like Orphism, it was an offshoot of Cubism; color was of central importance and was allied with fragmented forms. It had its basis in the color principles of Chevreul, Blanc, Helmholtz and Rood. Although Russell and Macdonald-Wright used the term Synchromism in part to distinguish their efforts from Orphism, the influence of which they disclaimed, their own work pales some-

what in comparison to Delaunay's sophisticated *Windows* series of 1912. Although both Americans were undoubtedly aware of the influential color theories propounded by Delaunay, they appear to have formulated their own independent positions, much as Dove had in regard to Kandinsky. They issued a manifesto to this effect, proclaiming their adherence to the supremacy of color, at the time of their joint exhibition at Munich's *Der Neue Kunstsalon* in June 1913. If their theories had fully crystallized, their paintings had not, and it was not until their exhibition in Paris at the Galerie Bernheim-Jeune in October of the same year that their work began to approach abstraction.

The two Americans differed substantially from one another in their approach to color. The more radical of them, Russell, appears to have experimented with color before any exposure to Delaunay. By 1912, Russell was contemplating painting "solely by means of color and the way it was put down, in showers and broad patches, distinct from each other or blended, but with force and clearness, and with large geometric patterns, with the effect of the whole as being constructed with volumes of color."[1] This approach is conspicuously revealed in his color studies, if not yet apparent in his paintings. Where Russell seemed determined to pursue pure color invention to its utmost limits, ultimately bringing his forms to the point of total abstraction, Macdonald-Wright retained a Cubist scaffolding based upon the human form. This underlying structure endowed his works with a sense of circular movement, the full potential of which, however, remained unrealized. His atmospheric rendering of diaphanous planes of color which seem suspended in space contrasts strongly with Russell's opaque segments of pigment but are uniquely relevant to the color painting of the 1950's and 1960's. Macdonald-Wright's employment of Cubist techniques extended also to the use of kaleidoscopic color and fragmented forms to convey movement in a manner not unlike that of Duchamp in *Nude Descending a Staircase.* His work, however, remains far more abstract than Duchamp's.

Shortly after the Paris exhibition, Macdonald-Wright returned to New York and organized his last joint show with Russell. Held in March 1914 at the Carroll Galleries in

1 Quoted in William C. Agee, *Synchromism and Color Principles in American Painting: 1910-1930,* M. Knoedler and Co., Inc., New York, October 12-November 6, 1965, p. 19.

New York, this exhibition introduced Synchromist painting to America. Their collaboration subsequently dissolved, and the two artists drifted apart. Nevertheless, the color principles of Synchromism began to find imitators in America. Thomas Hart Benton, who had met Macdonald-Wright in Paris in 1909, renewed his acquaintance with him in New York in 1914 and was strongly affected by his color theories. While Benton ultimately repudiated this influence, it is tempting to postulate that he conveyed the basic principles of Synchromism to his most renowned pupil, Jackson Pollock. The rhythmic energy of Macdonald-Wright's painting, which had been inspired by Michelangelo's contorted figures, appears in a rigid format in Benton's work of the 1930's and bears an uncanny resemblance to the curvilinear interlace of the mature Pollock.

Another group, centered around Walter Arensberg, was concerned with a different esthetic. Unlike Stieglitz, Arensberg's activity did not begin until the Armory Show. In fact he was prompted by the exhibition to move his household to New York to be close to the art that fascinated him. The most influential among the European expatriates who frequented the Arensberg establishment was Marcel Duchamp. He encouraged the Arensbergs to establish a salon where both European expatriates and Americans could meet. The circle included the artists Albert Gleizes, Francis Picabia and Jean Crotti and such poets, critics and composers as Henri-Martin Barzun, Henri-Pierre Roché and Edgar Varèse. The Americans numbered among them the artists Man Ray, Charles Demuth, Joseph Stella, John Covert and Charles Sheeler, the poets Amy Lowell and William Carlos Williams and the dancer Isadora Duncan. The group was Dada oriented. Although not officially launched in Zurich until 1916, Dada activities were evident in New York and Paris several years earlier, the culmination of a nihilistic reaction to World War I. As a protest against the conventions of both art and society, Dada attempted to abandon order at all costs. To that end, Duchamp, who had been a skilled Cubist painter, renounced painting for Readymades, a series of commercial objects which he altered by changing their real context for an esthetic one. The *Bicycle Wheel* of 1913 is an early example

and one of many that constituted a frontal assault on art; with it, Duchamp opened to question a range of hierarchical values that had already been challenged in purely esthetic terms by Analytical Cubism. The Cubist assault on spatial illusionism was transfigured by Duchamp into a dialogue about the object. The painted representation of an object in illusionistic space was replaced by an ostensibly straightforward presentation of an object in tangible space. However, there is a paradox involved because the "real" object is placed in an implausible, inappropriate context, rendering it perversely unreal. These Readymades were highly influential for Jasper Johns and Robert Rauschenberg, to name but two of the artists most clearly affected by Dada, especially during its revival in the 1950's and 1960's.

The mischievous atmosphere that characterized Duchamp and his circle inspired both numerous pranks and outrageous public insults while at the same time fostering much that was experimental and innovative in art. Joseph Stella, an outstanding draftsman, inspired by the Dadaistic iconoclasm of the Arensberg circle, abandoned his predilection for European tradition and began to portray a city, the reality and tempo of which he sought to capture. Best known for his paintings of the Brooklyn Bridge, which were essentially an eclectic combination of Futurism and Cubism, Stella's real ingenuity is much more apparent in a lesser known body of work — the collages he began in the 1920's which uncannily prefigure some of the most advanced work of the 1940's and 1950's by artists such as Robert Motherwell and Robert Rauschenberg. Like Dove, who also produced some memorable collages at this time, Stella had more in common with Schwitters than with the formalist esthetic of Cubism. The chance aspect of Dada informed the collages of both Schwitters and Stella, lending them a sense of immediacy and a nostalgia for the real world alien to the more hermetic and rigorous structure of the Cubist *papiers collés.* Although he was less urbane than his European counterpart, Stella's love of the city rivaled Schwitters' own and was unparalleled among the New York artists of his time. From his affection for the commonplace and the banal Stella fashioned an evocative poetic elegy that paid homage to New York.

Dada inspired yet another aspect of American art during the 1920's. The Dada emphasis on the machine, meant as a parody of Western civilization, influenced a group of artists, who became known as the Precisionists, to use mechanical and industrial forms, albeit with more positive overtones, as the sources for their art. The Precisionists invented a machine art for the machine age. Although the Futurists before them had also celebrated the coming of the machine age, prophesying a new future for art and life, it was the actual presence of Duchamp and Picabia in New York that provided the immediate stimulus for the Americans. Furthermore, Picabia's *Mechanical Drawings* of 1915-17 were published in both Stieglitz' magazine, *291,* and in Picabia's own periodical, *391,* so they were readily available. Duchamp's *Chocolate Grinder,* of 1914 (fig.), and Picabia's *This Thing is Made to Perpetuate My Memory,* of 1915 (fig.), are typical examples of the Dada play on the machine which served both artists as the perfect weapon with which to make a satiric comment upon the nature of our society. To this end, they endowed the machine with human erotic potential. The emphasis on shock value and humor derived from explicit sexual content characterizes the work of both Duchamp and Picabia, who elevated the scandalous and the obscene to the realm of art. Dada force-fed the mundane, the prosaic and the outrageous in a calculated attack upon all forms of order — in society, politics and religion — which it held to be the enemy of art.

While Dada's iconoclasm did indeed constitute an artistic revolution, it was far too literary to attract the wholehearted enthusiasm of the American artists it touched. The mechanical objects of Duchamp and Picabia served as the prototypes for the Precisionists. Precisionism, which numbered among its adherents the artists Morton Schamberg, Charles Sheeler and Charles Demuth, portrayed subjects peculiar to American life in a crisp, lucid geometric style. Factories and house interiors, barns and trees, grain elevators and the circular cogs and wheels of machinery became the subject matter of their art and were rendered in a style that often revealed the influence of photography. Both Sheeler and Schamberg, in fact, supported themselves through their photography. While

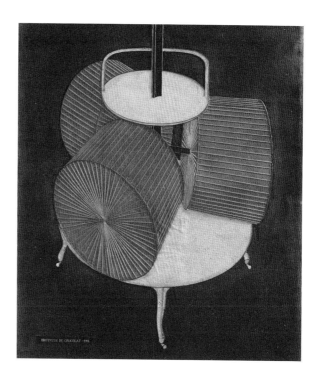

Duchamp, *Chocolate Grinder (No. 2).* February 1914. Philadelphia Museum of Art, The Louise and Walter Arensberg Collection.

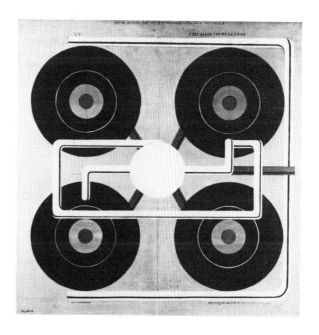

Picabia, *This Thing Is Made to Perpetuate My Memory.* 1915. Collection The Arts Club of Chicago.

Sheeler adopted a kind of reportage of the American landscape, rendering his subjects in a dry factual manner, Demuth remained faithful to a form of abstraction that brought him closer to Picabia and Duchamp.

A basically American sensibility characterizes Demuth however: his concept of abstraction was based upon the relatively realistic depiction of both man-made and natural forms held in dynamic tension with an underlying structure of Cubist planes. Demuth's works are basically straightforward, without the negative social and political overtones of Dada. An admirer of Duchamp, Demuth was greatly impressed with his good workmanship, but it was Marsden Hartley, with whom he vacationed in Bermuda in 1917, who had the greater influence on his work. Hartley was then painting his most abstract emblematic works and, while they have no direct bearing upon Demuth, their geometric simplification must have helped him move away from the lyrical representation that he practiced before 1917. At this time, Demuth began his *Bermuda* watercolor series, creating abstract linear patterns in the recesses of which are nestled fragments of forms such as trees and barns. The nature of the medium and his choice of colors relates the series to the Impressionists and Cézanne, but the crispness of modelling renders the work peculiarly American and brings it close to the other Precisionists.

The rapid growth and proliferation of experimental art in America was abruptly curtailed by World War I. Cut off from Europe by the war, American artists began to feel increasingly isolated and assumed a chauvinistic attitude, reflecting the general mood of the country. Disillusioned by a lack of response to avant-garde art, Stieglitz closed his gallery in 1917, and the Arensbergs abandoned New York for California in the 1920's. The *Société Anonyme,* established by Katherine S. Dreier, Marcel Duchamp and Man Ray in 1920, was the outstanding exception to an otherwise dismal scene. The *Société Anonyme* mounted a series of exhibitions in New York that featured Kandinsky, Klee and the Dadaists, Constructivists and Suprematists from Europe and such American artists as Man Ray, Patrick Henry Bruce, Jay van Everen, Jan Matulka, Joseph Stella, Marsden Hartley, Henry Fitch Taylor and John Covert.

Despite the vigorous activity of this organization, which appeared to have taken over the functions of both Stieglitz and Arensberg, artists like Thomas Hart Benton were to set the standard for American art during the 1920's and 1930's. Benton, who had initially embraced avant-garde art with total enthusiasm, turned violently against abstraction after World War I. His reaction was symptomatic of the times and reflected the conservative mood of the Depression, for even many of the leading artists of the avant-garde — O'Keeffe, Macdonald-Wright, among others — returned to representation. This climate prevailed until World War II. Two movements, the Regionalism favored by Benton, Grant Wood and John Steuart Curry and the American Scene painting of Reginald Marsh, Alexander Brook, Isabel Bishop and the brothers Isaac, Moses and Raphael Soyer, dominated the artistic scene. Yet there were artists like Stuart Davis who continued to work in the spirit of the avant-garde and whose creative efforts were to play a crucial role in the development of such a key figure of the New York School as Gorky.

A student of Robert Henri, Davis' career spanned an entire half-century and represents an extraordinary effort to reconcile themes derived from the American scene with the most sophisticated Cubist abstraction. By 1921, in works like *Untitled (Greek)* (cat. no. 58), Davis began to use collage or painted representations of collage elements, in a manner similar to the *papiers collés* of Picasso and Braque. In this piece and in related paintings of the time he introduced words and letters to emphasize the flatness of the picture plane, much as the Cubists had. He chose commercial products such as the cigarette wrapper for *Lucky Strike,* his most famous motif of the 1920's, and depicted them in a crisp manner close to the style of the Precisionists. However, like Gerald Murphy whose *Razor* of 1924 is an equally successful fusion of figuration and abstraction, Davis flattened form in space with his painterly equivalent of collage in a manner that set his work totally apart from the Precisionists. The elements Davis took out of context he recombined to form a new and personal abstraction which culminated in his brilliant work of the 1950's, of which *Package Deal* is an outstanding example.

Although the gouache (cat. no. 67) is a study for the painting of the same name, it is amazingly complete and, as such, is an important document of the artist's method of proceeding from collage to painting, a process that survives today in the not unrelated work of Roy Lichtenstein.

In 1927, Davis began his famous *Eggbeater* series. Convinced that the elements in his work could have dual functions — color could serve as space, line as direction, plane as color and form, and form could be interchangeable with space[2] — he arranged a still-life group composed of an eggbeater, a rubber glove and an electric fan which he rearranged throughout the course of a year. *Eggbeater No. 1* (cat. no. 61), a gouache, is an earlier version of the oil, *Eggbeater No. 2* of 1927 (fig.); it allows one to understand just how important Davis' preliminary studies were to his finished paintings. Davis said that "Color must be thought of as texture which automatically allows one to visualize it in space"[3] and it was this "color-space," as he later called it, which he obviously derived from his experiments with collage. Thus the inherent two-dimensional nature of collage enabled him to reconcile form and space in his paintings. His ink drawings of the 1930's were also essential to the realization of his paintings — both as a means of experimentation and final planning. In a drawing like *Davits,* of 1932 (cat. no. 65), for example, the presentations of forms from multiple viewpoints and the underlying structure of lines and planes are carefully adjusted so that their potential ambiguity is resolved in favor of the all-over unity that characterizes his painting.

The *Eggbeater* series represents Davis' breakthrough into his mature style. In the years that followed he proved himself to be fully aware of the sights and sounds of American life, capturing such uniquely American idioms as jazz and the pulse of the city. His color evolved from the primaries that he favored in the 1930's to a more hedonistic usage of brilliantly saturated pigments, obviously inspired by Matisse. Concurrently he developed faceted forms which in their liveliness paralleled the increasing intensity of his color, endowing his paintings with an energy unique in American painting of the time. The fierce vitality of his work represents his triumph over his earlier limitations as a

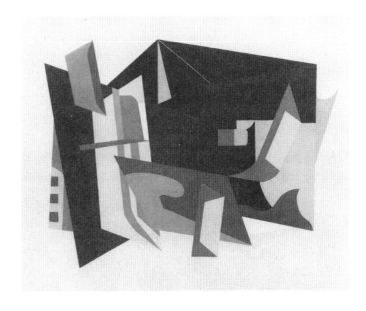

Davis, *Eggbeater No. 2.* 1927. Collection Whitney Museum of American Art, New York.

2 E. C. Goossen, *Stuart Davis,* New York, 1959, p. 22.
3 ibid.

painter and makes him the premier artist of the period between the first and second waves of the American avant-garde. Gorky, one of the first to recognize Davis' genius, wrote of him in 1931, characterizing him as one of the besieged artists of the time, condemning the "critics, artists, and public suspended like vultures, waiting in the air for the death of the distinctive art of this century, the art of Léger, Picasso, Miró, Kandinsky, Stuart Davis."[4]

American painting of the 1930's, whether the routine academicism of the regional scene painters or the Neo-Plasticism of the American Abstract Artists, offered little to the painters of the New York School, who later became identified as Abstract Expressionists. Many of this pioneer generation of Abstract Expressionists had in fact practiced some form of representational painting during the Depression years, often under the auspices of the WPA. It was in a spirit of rebellion, not only against the prevailing American art but also against their own early efforts, that they began the search for a new means of expression. The arrival of many of the major European painters at the time of World War II was the catalyst for their revolt. The Surrealists — Ernst, Tanguy, Matta, Masson and the poet laureate of the movement, Breton — came en masse. Duchamp was of course already active here; Léger and Mondrian lived and worked in New York during the war. They brought with them their enormous vitality and wealth of ideas and a sense of the entire history of European painting.

The presence of the Europeans, Josef Albers and Hans Hofmann who settled in New York in the early 1930's, cannot be underestimated, for both artists brought to the States an encyclopedic view of twentieth-century art. This kind of sophistication and knowledge had not been available among even the most avant-garde artists before World War I. Albers became an important force in American art when he took over the chairmanship of the Art Department at Black Mountain College in 1933. At Black Mountain, Albers stressed the type of curriculum he had taught at the *Bauhaus* in Germany and, in general, continued to advocate the multi-faceted approach of the *Bauhaus* curriculum. Black Mountain became the fulcrum of avant-garde activities in America and included among its

faculty such important figures as Willem de Kooning, Franz Kline, Robert Motherwell, Jack Tworkov, Buckminster Fuller, Clement Greenberg and John Cage. Unlike many artists of his time, Albers approached drawing as a problem clearly separate from the problems of painting. In doing so, he abandoned the issue of the "interaction of color" which he had confronted in his series of paintings, *Homage to the Square,* begun in 1949, and focused instead on the two-dimensional issues of drawing. His drawings, of which *Reverse + Obverse,* of 1962 (cat. no. 70), is a characteristic example, convert pictorial illusionism into a dialogue about the nature of perception. In these drawings, Albers arrived at formulations that were highly influential to the art of the 1960's. Donald Judd, one of the leading Minimalist sculptors, applied the ramifications of Albers' concept of two-dimensional illusionism to the rather unlikely area of sculpture and succeeded in producing a highly intelligent body of work.

Albers' pedagogical approach was in direct contrast to the largely intuitive theories advocated by Hofmann. Hofmann, who had opened his first school in New York in 1933, stressed his belief that painting was "forming with color." In his teaching, Hofmann emphasized the positive value of opposing forces — contrasting colors, positive and negative spaces, the dynamic versus the static, expansion versus contraction. For Hofmann, "every movement releases (in space) a counter-movement." According to this principle, to which he gave the now well-known name, "push-pull," a tension is created which could only be resolved by stabilizing the three-dimensional depth suggested by the forms in a painting with the two-dimensional surface of the picture plane. To resolve these inherent contradictions, he employed dramatic color, active paint handling and dynamic line. These characteristics and their successful resolution are evident in his drawings, such as *Ambush,* 1944 (cat. no. 73), as well as in his paintings. The impetuous energy of Hofmann's teaching and painting influenced not only his own students in New York but appears also to have been so pervasive as to have indirectly affected such a major figure as Pollock. This seems apparent from the rather close resemblance be-

4 Barbara Rose, *American Art Since 1900,* New York, Washington, D.C., 1975, p. 120.

tween a Hofmann of 1944 (cat. no. 74) and an ink and gouache that Pollock executed in Provincetown in the summer of 1945. Pollock's famous drip technique was in fact anticipated by Hofmann, as is evident from even the most casual comparison of these two drawings.

With the war on, cut off from Europe, the Surrealists were the major influence on the Americans. The personal contact with the Surrealists, although limited, provided direct access to their work and assured the fledgling American painters that the legendary Europeans were, after all, human. Arshile Gorky, Jackson Pollock, Willem de Kooning, Robert Motherwell, Mark Rothko and Barnett Newman were among the earliest admirers of the new art from Europe. For all of them, it was an exhilarating time, a moment in history that gave them the freedom and challenge they needed to cut the cord that tied them to a provincial American art. From this alliance with European art and thought they created, in a monumental effort, a brilliant new American art.

Like the Surrealists, the Abstract Expressionists practiced automatism, a technique that encouraged chance and random or spontaneous images free from "thought's control." It was this method that helped artists like Pollock and Gorky free themselves from the constraints of traditional painting.

Gorky's progress towards his mature expression was, like Stuart Davis', a long and arduous one, full of self-criticism, an evolution that became a tortured model for the avant-garde of the 1950's and 1960's. In the course of copying such artists as Picasso, Miró and Kandinsky, Gorky evolved an automatic technique which allowed him to externalize his inner world of fantasy. Gorky was always a prolific draftsman and usually began a painting with a series of carefully prepared drawings. From the drawings he selected biomorphic forms which in the paintings he rearranged and delicately balanced with modulated patches of color.

In the summer of 1943, Gorky visited his in-laws on their farm in Virginia. There he drew directly from nature, saying that he had started to "look into the grass." As James Johnson Sweeney stated, "The product was a series of monumentally drawn details of what one might see in the heavy August grass. . . . a new vocabulary of forms on which he is at present drawing for a group of large oil paintings."[5] During the summer and fall of 1946, Gorky made over three hundred drawings on the farm in Virginia while recuperating from an operation. The wealth of drawings Gorky produced in the period of his mature style, 1943-48, attests to the high quality of improvisation which he cultivated. It was the mysterious and moving association Gorky made between his quasi-abstract and quasi-anthropomorphic forms that brought abstraction in American art to a new level of greatness. *Summation,* of 1947, in The Museum of Modern Art, New York, is his masterpiece. Measuring almost eighty by over one hundred inches, it brings drawing into the arena of painting and prefigures the scale to which much recent drawing now aspires. *Summation* is Gorky's statement of his telling awareness of the boundaries between painting and drawing, and it reveals his extraordinary ability to visualize the potential interconnection between the two mediums.

Pollock's working method differed radically from Gorky's in that he did not proceed from working drawings to paintings, preferring to be directly and totally engaged in the act of painting. Yet the style he evolved in his paintings is decidedly linear and therefore has some bearing on his drawings. The same delicate skeins of his paintings appear in his drawings, although here the limitation of size restricts the sense of movement that pervades his canvases. Pollock, like Gorky, is a master of scale, and although he did not choose to make large drawings, the images are perfectly suited to the format of the page. In the drawings, as in the paintings, one can trace the evolution of Pollock's style from the early proto-Surrealist phase (cat. no. 88) to the work of his mature period, 1947-50 (cat. no. 93), to a later stage in which he reintroduced figuration while continuing all-over abstraction.

Automatism was also of central importance to Motherwell, who was, in fact, instrumental in introducing this method to many of the New York School. In defining the role that automatism played in the development of most of the leading Abstract Expressionists, Motherwell stated:

5 James Johnson Sweeney, "Five American Painters," *Harper's Bazaar,* vol. 78, April 1944, pp. 76ff.

In one of Motherwell's germinal works, *Pancho Villa, Dead and Alive,* of 1943 (fig.), many of the forms characteristic of his later oeuvre appear. The random drips and spatters signify an acceptance of the Surrealist attitude that chance and accident are valuable concomitants of spontaneity. On the other hand, the logical and coherent structure, derived from Cubism, in which the picture is divided into quasi-geometric compartments, exerts a significant control over accidental effects. Motherwell began to make collages in 1943 when he, together with Pollock and William Baziotes, was invited to participate in a major exhibition of collage at Peggy Guggenheim's *Art of This Century* gallery. Although none of them had ever worked with collage, the idea was intriguing and Motherwell and Pollock decided to collaborate. Although Pollock rarely used collage after this initial experiment, it became an integral part of Motherwell's work.

Pancho Villa, Dead and Alive is notable for, among other things, its frontality, which asserts the rectangular picture plane, and for its suspended ovoid shapes, which are predictive of his later work. The prototype for the *Elegy* series, *At Five in the Afternoon,* of 1949 (cat. no. 142), clearly demonstrates Motherwell's predilection for the irregular shape regularly disposed on the picture plane. Characteristic of both Motherwell's collage and drawing, and typical of his work in general, is the contrast between roughly geometric shapes and loose brushy areas. Shapes, while simple, are imbued with a painterly improvisation that allows both form, gesture and color their infinite freedom of expression. Motherwell has elaborated upon the Cubist *papiers collés* and brought the sensibility of collage to his paintings. In doing

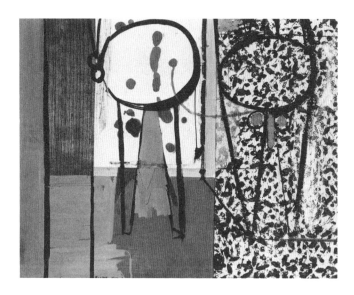

Motherwell, *Pancho Villa, Dead and Alive.* 1943.
Collection The Museum of Modern Art, New York.

6 Robert Motherwell, "The Modern Painter's World," *Dyn,* no. 6, November 1944, p. 13.

so, the nuance of line, shape, color and edge reach a new level of refinement.

De Kooning's contribution to drawing is equally far reaching. His drawings and paintings are extremely close to each other in many respects. Often brutal, sometimes lyrical, his drawings are replete with the frenzied brushstrokes characteristic of his paintings. Because of de Kooning's preference for easel scale — he has never been as involved with large scale as Pollock, Newman, Rothko and Clyfford Still — the connections between his drawings and paintings seem very close. Moreover, his paintings partake as much of the qualities of drawing as do drawings themselves, in the sense that his forms are carried by line. And he uses the same materials, often interchangeably, in both his paintings and drawings, drawing in his paintings, painting in his drawings, and using collage in both.

De Kooning's dependence upon line is especially apparent in his work of the 1930's and 1940's, such as his portrait of *Elaine de Kooning,* ca. 1940 (cat. no. 97), which indicates his extraordinary, if conventional, skill as a draftsman. He broke loose from this conventional realistic kind of portrayal as he turned toward an often Balthus-like deformation of the figure which had begun to interest him several years earlier. In *Working Man,* of ca. 1938 (cat. no. 96), for example, the distortion, in which the parts of the figure are disjointed to the extent that they seem unreal and resemble mannekins, is such that although the figure is still recognizable, it clearly anticipates his later interest in abstract form. As de Kooning evolved further, in the late 1940's, he abandoned even this degree of realism and in his drawings, as in his paintings, he eschewed figuration for total abstraction. Then, in the early 1950's he returned once again to the figure and produced his *Women* series. The distortion that characterizes this series is vastly different from his earlier, more tentative approach. Parts of the anatomy — breasts, mouths, etc. — are detached from the rest of the body and repositioned, seemingly at random, at various places in a work. In this respect, de Kooning, like many of his contemporaries, was influenced by collage; in fact, his working method often consists of cutting or tearing, shifting and reassembling a series of images until he arrives at a relationship between the parts that is both visually and emotionally compelling.

Kline, like de Kooning, was concerned with gestural abstraction. Beginning in the late 1940's, Kline experimented with abstract sketches that were loose variations of his figure studies. At first a rather conventional artist, Kline had concentrated on the urban landscape, among other themes. By 1950, however, he had made the quantum leap from a somewhat timid realism to an extraordinarily sophisticated form of abstraction. Two portraits of the dancer Nijinsky reveal this remarkable transition. In the earlier portrait of 1947 (cat. no. 110), the dancer is depicted in a straightforward manner, but the sense of constraint, especially in Kline's handling of the contours of the figure, is readily apparent. In the later characterization, dating to around 1949, he freed his brushstrokes from the limitations of representation and gave free rein to a sense of momentum that more closely represented the dynamic force of the dancer than any realistic portrayal could accomplish. The evolution of Kline's mature style clearly depended upon the drawings; he enlarged his sketches and was so satisfied with the result that he decided to retain this procedure as his working method. Using this process, Kline magnified his brushstrokes into enormous, powerful trajectories that crisscrossed his canvases. The numerous drawings that he made on telephone book pages and newsprint were done in black enamel, a cheap, fast-drying house paint similar to that used by de Kooning at around the same time. Despite the fact that the drawings are much smaller than the paintings they do not suffer from a lack of scale. Indeed, like the paintings, they are, at their best, clearly embodiments of Kline's heroic form.

Although a contemporary and friend of many members of the New York School, Joseph Cornell stands very much apart from the mainstream of Abstract Expressionism. Influenced by the Surrealists and, to a lesser extent, by the Neo-Plasticism of Mondrian — a not implausible combination in view of the fact that Cornell began to mature as an artist during the 1930's when both movements were at their peak — it is from Surrealism that his collages most clearly derive. It was soon

Cornell, *The Crystal Cage: Portrait of Blondin,*
executed for *View,* second series, no. 4, January
1943.

after Cornell first saw Ernst's collage-novel,
La Femme 100 têtes, of 1929, that he began
his own first collages. Done in the style of
Ernst, they affirm the Surrealist practice of
irrational juxtaposition of elements in which
images drawn from different contexts and of
radically differing scale are united in a
whole, the totality of which can only be
comprehended with the aid of the imagina-
tion. Rather than disposing the fragments of
collage as separate elements upon the pic-
ture plane, as the Cubists had, Cornell, like
Ernst, pasted them together as a unified
image. In collages of this period, around
1931, the illogical scale of the elements might
be expected to act as an irritant to the spec-
tator. Because of the seeming innocence of
Cornell's images, however, the extremely
disturbing psychological effects of Ernst's
collage-novel are, however, absent from his
work. They are a series of dream-like images
imbued with a mood of reverie, a nostalgic
longing for the past quite different from the
grotesque and nightmarish visions of Ernst's
collage-novels.

Although Cornell continued to produce
collages after the 1930's, he did so inter-
mittently, preoccupied for the most part with
a series of box constructions that constitute
the largest part of his production. He turned
to collage again in 1943, with *The Crystal
Cage: Portrait of Berenice,* published in the
"Americana Fantastica" issue of *View* maga-
zine (for example, fig.). This work consists of
a word portrait of the *Pagode de Chante-
loupe,* a chinoiserie of the late nineteenth
century, accompanied by a series of collages
and related documents. In the late 1950's,
Cornell returned for a longer period to col-
lage and produced, for the first time, the two-
dimensional equivalent of his box construc-
tions. In these collages Cornell substituted
an exquisite adjustment of his poetic meta-
phors to the picture plane for the sense of in-
finite space conveyed by the placement of
real objects in the three-dimensional boxes.
Although his collages lack the mysterious
space of his boxes, they retain the same
symbolic connections between images. The
fantasy world of his collages, like his boxes,
exists at the highest level of visual poetry.

The transition from Abstract Expressionism
to Pop Art could not have appeared more
startling when it first occurred in the early

1960's. The loose amorphous style of the first generation of the New York School was replaced by a more precisely executed technique, abstract forms were rejected in favor of the commonplace object and the heroic concepts of the Abstract Expressionists were abandoned for the kitchen culture of the Pop artists. The objectness of Pop is the direct outcome of the influence of Rauschenberg and Johns. Both artists placed maximum emphasis on the actual physical attributes of an object. Johns' great contribution was to make a flag or a target both a literal object and a statement about the rectangle. His direct focus on the status of a flag or a target as object was crucial to the development of many artists working in the early 1960's. Several of them, most notably Allan Kaprow and Claes Oldenburg, experimented with Happenings and used objects as important props in their performances. Alone among the so-called Pop artists, Roy Lichtenstein flattened the object and effected a new reconciliation between it and the picture plane. This allows the object both its original identity (we retain our sense of the object as a three-dimensional form) and a new abstract one. Lichtenstein integrated the object with the picture plane by means of a single image against ground format derived from Picasso. To successfully transform the subject, an equilibrium between the original object and its translation must be maintained. Lichtenstein achieves this by conjoining a "real" image and an abstract style. This "real" image brings with it all the data we need to recall the actual object. The abstract style, on the other hand, transcends the literalness of the object. This allows Lichtenstein to reconcile the actual object and the image of the object on the picture plane. This is a crucial departure from Johns who wanted to make the flag or the target a literal object. For Lichtenstein, the less apparent the change from the original subject, the more abstract the style, the more effective the concept of transformation.

The restrictions of the drawing medium dovetail with Lichtenstein's innate graphic sensibility. His drawings of 1961 to the present form a cogent, if selective, documentation of the development of his general style. The drawings are similar in conception to his paintings and in some cases identical in sub-

ject. Granted these fundamental similarities, there are some striking differences between his drawings and his paintings. The drawings are, with the exception of the sketches, not intended as preparation for the paintings but as a fresh investigation of the material. The most notable distinction between the drawings and paintings is the elimination of color in the larger "finished" drawings. Lichtenstein suppressed color primarily to make these drawings a statement clearly distinct from his paintings, as well as to emphasize the fact that "drawing" is a unique concept within the larger context of art. Another reason for his decision to work in black and white can be most easily explained by the artist's often quoted statement: "I want my painting to look as if it had been programmed. I want to hide the record of my hand." One could say, therefore, that black and white offered the equivalent resistance on paper that his use of red, yellow and blue and the Ben Day dot pattern established in his paintings, a facsimile of mass-produced "commercial" color and line. Yet he has succeeded in overcoming this resistance to make paintings and drawings of great originality.

Lichtenstein systematically investigates the meaning of drawing. The closest parallel to this procedure is Johns' consistent approach, effected through his elaboration of the multiple meanings and uses of gray, though this attitude is also evident to a certain extent in the work of Cy Twombly. (It is noteworthy that this investigation of the medium, which actually began with Johns and Rauschenberg, became the basis for the conceptualization of the 1960's and early 1970's.)

Andy Warhol's use of banal subjects is, like Lichtenstein's, based upon an acceptance of the mass media as a tool for art. His Campbell's Soup cans, dollar bills, portraits of movie stars and drawings of Mao lack the hierarchical qualities of traditional subjects and have, instead, a common denominator — their value as sensational or disturbing images. Warhol's drawings, again paralleling Lichtenstein's, reveal a fairly straightforward approach. In contrast to his flashier paintings, in which the use of silk-screen and "day-glo" color creates a tarnished but brilliant presence, Warhol restricts himself,

23

in his drawings to relatively simple means, often using only pencil and inexpensive paper. Unlike Lichtenstein, Warhol's attitude about drawing is quite casual, at least ostensibly, and he avoids the type of finish that is characteristic not only of Lichtenstein but of Johns and Rauschenberg as well.

For Oldenburg, drawing serves two functions: they are either notations with diaristic implications or sketches for projects such as his monuments. The latter are usually finished works in themselves, despite their role as sketches. An incessant draftsman, Oldenburg records his impressions of the life around him. His drawings, a perceptual response to the transitory, complement the sense of permanence conveyed by his monuments. Oldenburg began the monument drawings in 1965 and wrote:

A large part of the pleasure of drawing is the awareness of shifting scale. Drawing is miniaturistic, but while drawing one imagines differences of scale. One effect of the monument drawings is an imaginary expansion of the drawing scale. . . . The "monuments" — a conceptual direction — move from simple placement of favorite objects onto the landscape to more studied relations of object and site, for example, the ironing board echoes the shape of Manhattan Island. Some of the juxtapositions are means of social comment, often supported by written material accompanying the drawings. Some "drawings" consist of text alone, a sort of prose poetry describing a visual effect.[7]

For Oldenburg, drawing is as much an integral part of his sculpture as his sculpture is the direct outcome of his drawing. Oldenburg's drawings, like Warhol's and Lichtenstein's, usually depict a single object more or less centered on the page. Unlike the other two artists, however, Oldenburg attaches great importance to flourish and the manipulation of his materials for a dramatic effect. If Warhol's drawings are the epitome of understatement, then Oldenburg's are pitched to a rather operatic climax. In this respect his drawings appear to be a more direct continuation of his earlier expressionistic work than related to his recent rather controlled sculpture. It is in his drawings, in fact, that we see his relationship to Abstract Expressionism. Oldenburg's detachment, which aligns him with the general attitude of Pop Art, resides in his use of banal subjects, rather than in his means of expression, which are relatively traditional in both drawing and sculpture.

Drawings and collages are of central importance in the work of Ellsworth Kelly; from the very first, he has been able to formulate his ideas in them. Far more than mere concepts, however, are revealed in these mediums. Although never intended as finished works, even the smallest, almost thumbnail sketch, is succinct and conclusive enough to reveal Kelly's intentions in his painting. The sketches are of further value in that they allow us to understand Kelly's reasoning as it evolved in them, as well as to compare it to his final process of elimination and selection in the paintings themselves.

Kelly's use of collage, from his first attempt in the medium in 1950, has been notable for the admixture of linear patterns, the introduction of solid, unbroken areas of color, chance composition and the combination of fragmentation with an all-over intensity that avoids a fixed center of interest. To make these collages, Kelly cut up his old drawings and threw them down. Guided by the resulting random order, he then rearranged them in a loose grid. The use of original drawings offered Kelly the opportunity to juxtapose diametrically opposed elements — the cut edge and the brushed mark, the mechanical and the consummately individual — the different qualities of which produced lively contrasts. The assembling of collages from many elements was the means by which he effected his innovative move away from the single, whole image to the disintegration of that image into minute units which were then reassembled into another totality.

Kelly's extensive use of collage during 1951-52 enabled him to quickly test some of his theories. Collage became for him simply a convenience, useful in mapping out new directions. He worked with chance collage into 1952, experimenting first with hundreds of fragments, then reducing the units to a few elements. As he refined the number of units, his emphasis on color became more pronounced. His use of color squares and drastic simplification of elements led him to recognize that separated panels could carry his color while retaining their integrity as shapes. Thus, his early collages were especially important in that they suggested the later innovations of his panel paintings.

7 Quoted in Gene Baro, *Claes Oldenburg Drawings and Prints,* London 1969, p. 19.

Kelly tested color arrangements and variations in black and white and experimented with horizontal and vertical stripe compositions which were never made into paintings (cat. no. 182). Although he could work out the general proportions and spatial arrangements of his forms with collage, the colors themselves were rather rudimentary. Since he pasted up whatever colored papers he could find, it became necessary to determine the appropriateness of his color and to make the final adjustments on the canvas. He discovered that scale was a vital factor in determining the outcome of his color relationships and that the same colors situated next to one another in a small sketch or collage changed dramatically when enlarged. Since he worked with color intuitively, it was impossible to foresee the outcome of a painting solely in a collage, although his collage and painting are mutually interdependent.

Drawing has continued to change radically: in the late 1960's, it began to approximate painting. This development, which evolved from the concepts of Minimal art, appeared to deny all conventional approaches to drawing. Use of large scale and placement on areas like walls and floors, formerly appropriate exclusively to painting and sculpture, became characteristic of drawing. This synthesis, although recent, is symptomatic of the drastic changes that have occurred throughout the twentieth century.

The diversity which has characterized American art in the astonishingly brief period of fifty-odd years has made it the important force for change that is at the very heart of the avant-garde. Yet the work of O'Keeffe, Dove and Macdonald-Wright is as fresh as the very latest achievements of Lichtenstein and Kelly. For, while innovation is fundamental to its nature, the true value of the avant-garde lies beyond change. These twentieth century artists, timely, diverse and forward looking, have created a timeless art.

Works in the exhibition

The works in this exhibition convey both their unique individuality as drawings and their relationship to the painting and sculpture of their time. Above all, they are representative examples of the twentieth-century avant-garde. Limitations of space and considerations of compatibility of works shown have made it necessary to restrict rather rigorously the number of artists in the exhibition. The choice of artists has, of course, been determined by the preferences of the curator. While this exhibition cannot attempt to present every important avant-garde artist, it does strive to survey in some depth, and in a personal fashion, many of the most outstanding achievements in American art.

† Indicates illustrated in color
* Indicates illustrated in black and white
 All works are on paper unless otherwise noted

Index to the Checklist

24 O'Keeffe, *Over Blue*. 1918 or 1919

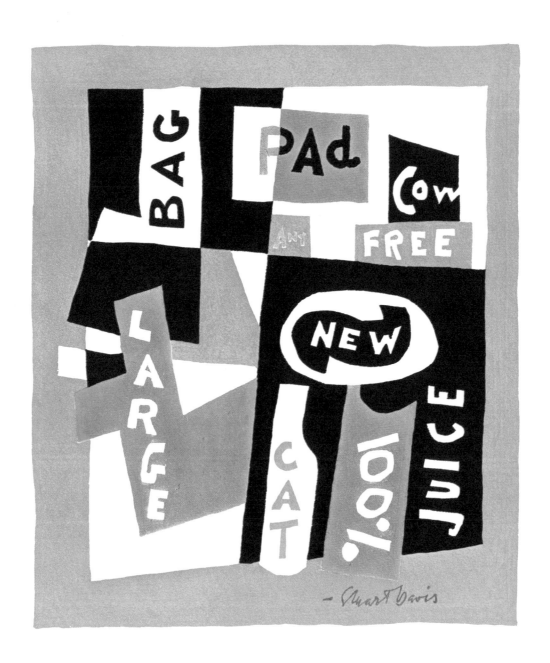

67 Davis, *Study for Package Deal*. 1956

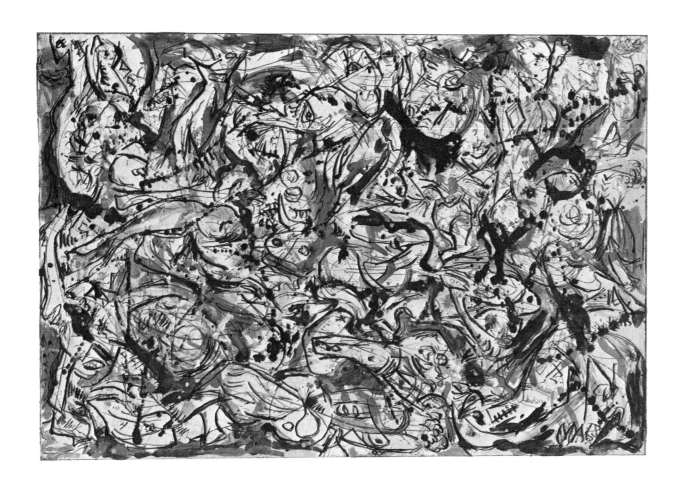

90 Pollock, *Untitled*. Summer 1945

29

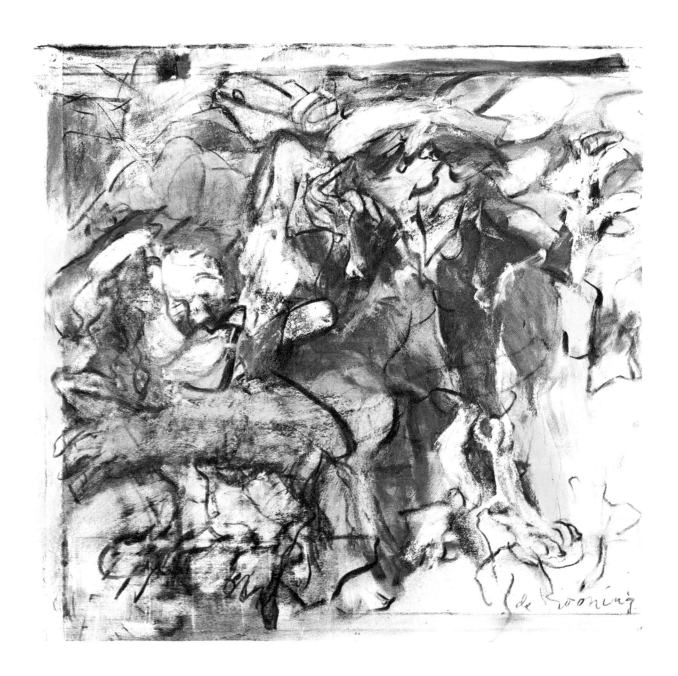

109 de Kooning, *Untitled (Figure in Landscape).* 1974

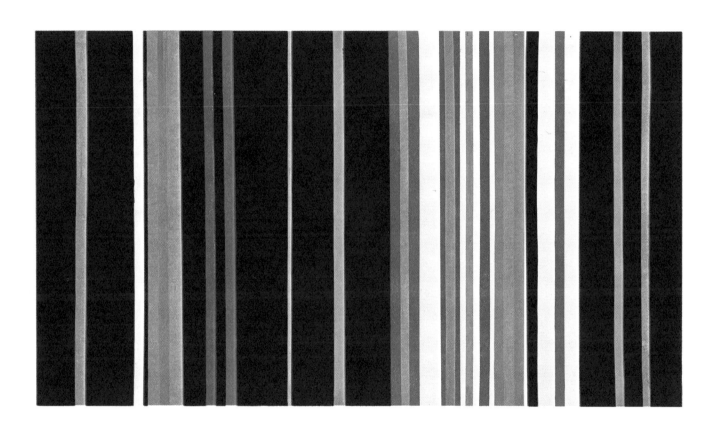

182 Kelly, *Color Strips Arranged by Chance*. 1951

Joseph Stella

1 *Underpass.* 1908
Charcoal, 11⅜ x 16⅜"
Private Collection

*2 *Song of the Nightingale.* 1918
Pastel, 18 x 23⅛"
Collection The Museum of Modern Art,
New York, Bertram F. and Susie
Brummer Foundation Fund

*3 *Collage No. 8.* 1918-22
Collage of paperboard with watercolor,
16⅝ x 10⅝"
Collection Museum of Art, Carnegie
Institute, Pittsburgh

4 *Marcel Duchamp.* c. 1920
Silverpoint, 27¼ x 21"
Collection The Museum of Modern Art,
New York, Katherine S. Dreier Bequest

5 *Profile.* 1922
Collage of paper with watercolor,
10¾ x 7"
Lent by Andrew Crispo Gallery, New
York

*6 *Macchina Naturale No. 4: Related to
"New York Interpreted, The Sky-
scrapers."* 1923
Collage of photographs, 11½ x 9¼"
Lent by Andrew Crispo Gallery, New
York

*7 *Cypress Tree.* c. 1927-28
Gouache and pencil, 41 x 27⅜"
Collection Hirshhorn Museum and
Sculpture Garden, Smithsonian
Institution, Washington, D.C.

8 *Macchina Naturale No. 5.* 1928
Collage of photographs, cigar box label
with oil on paperboard, 12½ x 8¼"
Lent by Andrew Crispo Gallery, New
York

9 *Macchina Naturale No. 9.* 1936
Collage of paper and leaf with water-
color, 11¾ x 13"
Lent by Andrew Crispo Gallery, New
York

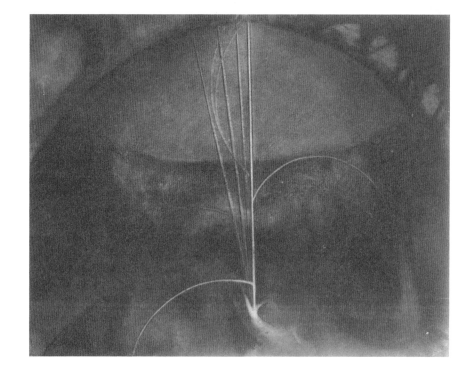

2 Stella, *Song of the Nightingale.* 1918

3 Stella, *Collage No. 8.* 1918-22

6 Stella, *Macchina Naturale No. 4: Related to "New York Interpreted, The Skyscrapers."* 1923

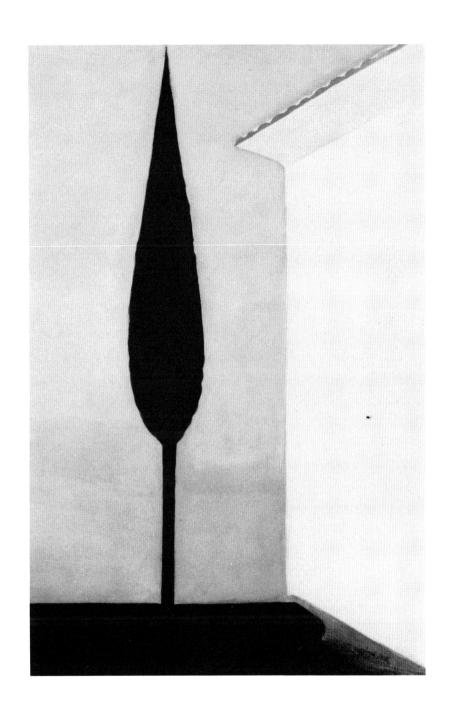

7 Stella, *Cypress Tree*. c. 1927-28

Arthur G. Dove

*10 *Abstraction No. 2.* c. 1911
Charcoal, 20⅝ x 17½"
Collection Whitney Museum of American
Art, New York

11 *Abstraction, Untitled.* 1915
Charcoal, 20¾ x 17½"
Collection Henry and Maria Feiwel

12 *Plant Forms.* 1915
Pastel on linen, 17¼ x 23⅞"
Collection Whitney Museum of American
Art, New York, Gift of Mr. and Mrs. Roy
R. Neuberger

13 *Sun on Water.* 1917-20
Charcoal, 17 x 20"
Collection Michael Scharf, New York

*14 *Nature Symbolized.* c. 1917-20
Charcoal, 20½ x 17"
Collection Mr. and Mrs. Sidney Sass

15 *A Walk Poplars.* 1920
Pastel on linen, 20¾ x 17½"
Lent by William Zierler Gallery,
New York

*16 *The Critic.* 1925
Collage of paperboard, newspaper,
magazine illustrations, cord and velvet,
19½ x 12½"
Lent by Terry Dintenfass, Inc., New York

*17 *Field of Grain Seen from Train.* 1931
Watercolor, 5 x 7"
Collection Baroness Minda de
Gunzburg, Paris

18 *Partly Cloudy.* 1941
Watercolor, 5¼ x 4"
Collection Dr. and Mrs. Victor D'Arc

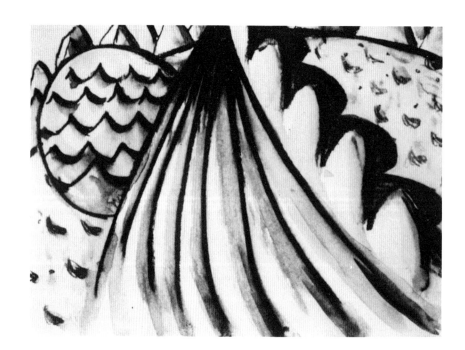

17 Dove, *Field of Grain Seen from Train.* 1931

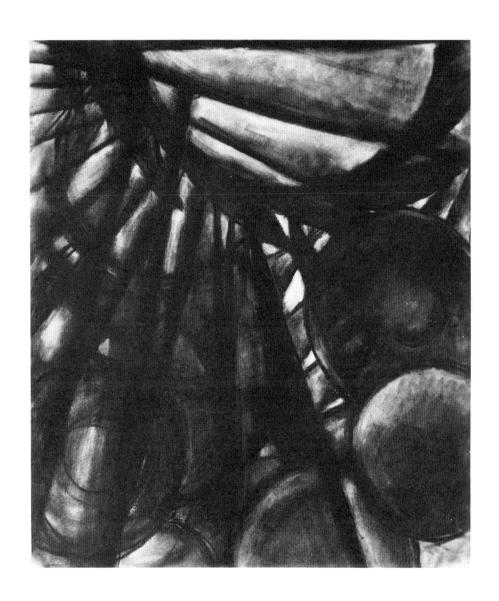

10 Dove, *Abstraction No. 2.* c. 1911

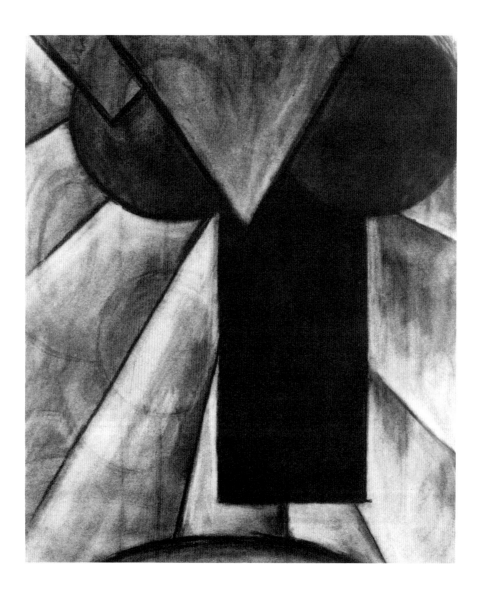

14 Dove, *Nature Symbolized.* c. 1917-20

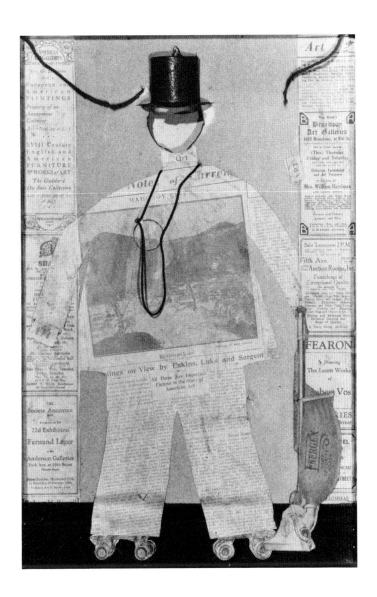

16 Dove, *The Critic*. 1925

Georgia O'Keeffe

*19 *Drawing No. 4.* 1915
 Charcoal, 24⅜ x 18⅝″
 Lent by Doris Bry, New York, for Georgia
 O'Keeffe

20 *Drawing No. 9.* 1915
 Charcoal, 25 x 19″
 Lent by Doris Bry, New York, for Georgia
 O'Keeffe

21 *Drawing No. 13.* 1915
 Charcoal, 24¾ x 18⅞″
 The Metropolitan Museum of Art, New
 York, The Alfred Stieglitz Collection,
 1949

22 *Evening Star No. IV.* 1917
 Watercolor, 9 x 12″
 Lent by Doris Bry, New York, for Georgia
 O'Keeffe

*23 *Evening Star No. VI.* 1917
 Watercolor, 9 x 12″
 Lent by Doris Bry, New York, for Georgia
 O'Keeffe

†24 *Over Blue.* 1918 or 1919
 Pastel, 27½ x 21½″
 Lent by Doris Bry, New York, for Georgia
 O'Keeffe

25 *Single Alligator Pear.* 1923
 Pastel, 12 x 10″ (sight)
 Lent by Doris Bry, New York, for Georgia
 O'Keeffe

26 *Alligator Pears in Basket.* 1923
 Charcoal, 25 x 19″
 Lent by Doris Bry, New York, for Georgia
 O'Keeffe

*27 *Drawing X.* 1959
 Charcoal, 24¾ x 18⅝″
 Collection The Museum of Modern Art,
 New York, Gift of the artist

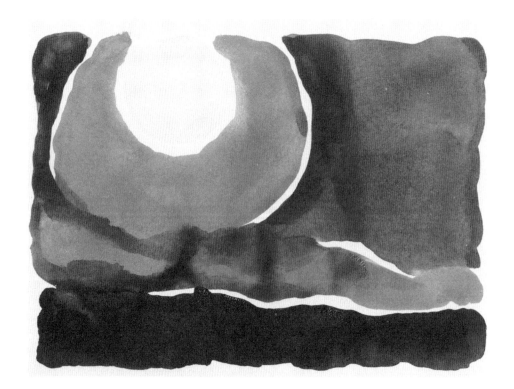

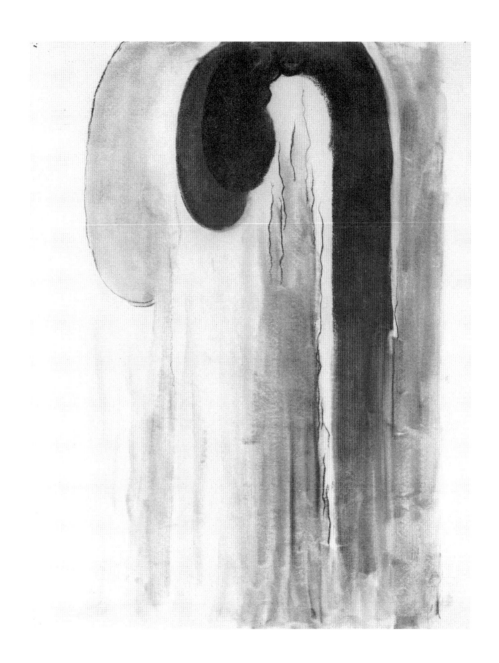

19 O'Keeffe, *Drawing No. 4.* 1915

41

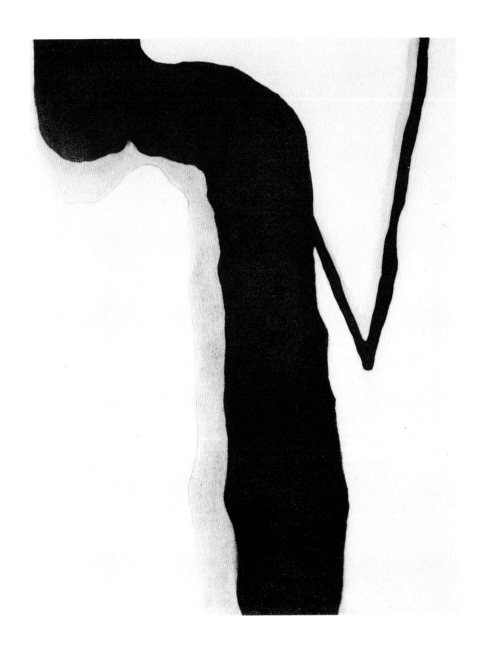

27 O'Keeffe, *Drawing X*. 1959

Charles Demuth

*28 *Bermuda No. 1, Tree and House.* n.d.
Watercolor, 10 x 13⅞ "
The Metropolitan Museum of Art, New
York, The Alfred Stieglitz Collection,
1949

29 *Bermuda No. 2, The Schooner.* 1917
Watercolor, 10 x 13⅞ "
The Metropolitan Museum of Art, New
York, The Alfred Stieglitz Collection,
1949

30 *Flowers.* 1919
Watercolor, 13¾ x 9¾ "
The Columbus (Ohio) Gallery of Fine
Arts: Ferdinand Howald Collection

*31 *Machinery.* 1920
Tempera and pencil on paperboard,
24 x 19⅞ "
The Metropolitan Museum of Art, New
York, The Alfred Stieglitz Collection,
1949

32 *Stairs, Provincetown.* 1920
Gouache and pencil on paperboard,
23½ x 19½ "
Collection The Museum of Modern Art,
New York, Gift of Abby Aldrich
Rockefeller

*33 *Roofs and Steeple.* 1921
Watercolor, 14¼ x 10⅜ "
Collection The Brooklyn Museum,
Dick S. Ramsay Fund

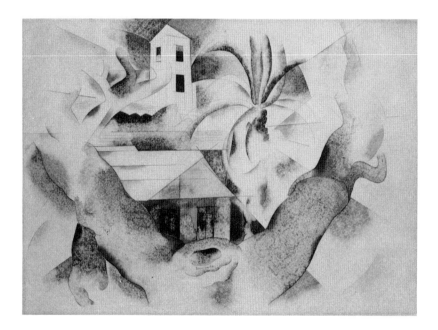

28 Demuth, *Bermuda No. 1, Tree and House.* n.d.

31 Demuth, *Machinery*. 1920

33 Demuth, *Roofs and Steeple*. 1921

Marcel Duchamp

34 *"The."* 1915
Ink, 8¾ x 5⅝"
Philadelphia Museum of Art, The Louise
and Walter Arensberg Collection

35 *Handmade Stereopticon Slide (Hand
Stereoscopy).* 1918-19
Rectified Readymade of pencil over
photographic stereopticon slide
mounted on paperboard, 2¾ x 6¾"
Collection The Museum of Modern Art,
New York, Katherine S. Dreier Bequest

36 *Tzanck Check.* December 3, 1919
Ink, 8¼ x 15⅛"
Lent by Galleria Schwarz, Milan

37 *Beautiful Breath, Veil Water.* 1921
Collage of photographs, 11⅝ x 7⅞"
Collection Carl Frederik Reutersward,
Lausanne

*38 *Disks Bearing Spirals.* 1923
Ink and pencil on paper mounted on
paperboard, 42⅝ x 42⅝"
Seattle Art Museum, Eugene Fuller
Memorial Collection

*39 *Obligations pour la Roulette de Monte
Carlo (Monte Carlo Bond).* 1924
Collage of photograph on color
lithograph, 12¼ x 7¾"
Collection The Museum of Modern Art,
New York, Gift of the artist, 1939

40 *Bedridden Mountains.* 1959
Pen and pencil, 12⅝ x 9⅝"
Collection Robert Lebel, Paris

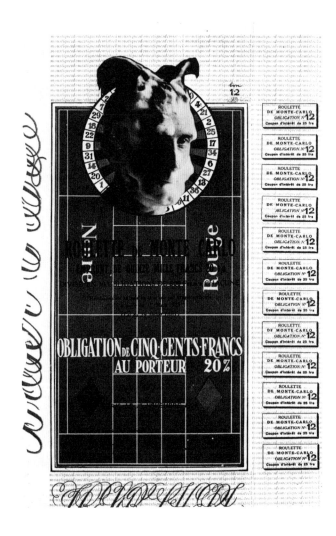

46

39 Duchamp, *Obligations pour la Roulette de Monte Carlo (Monte Carlo Bond).* 1924

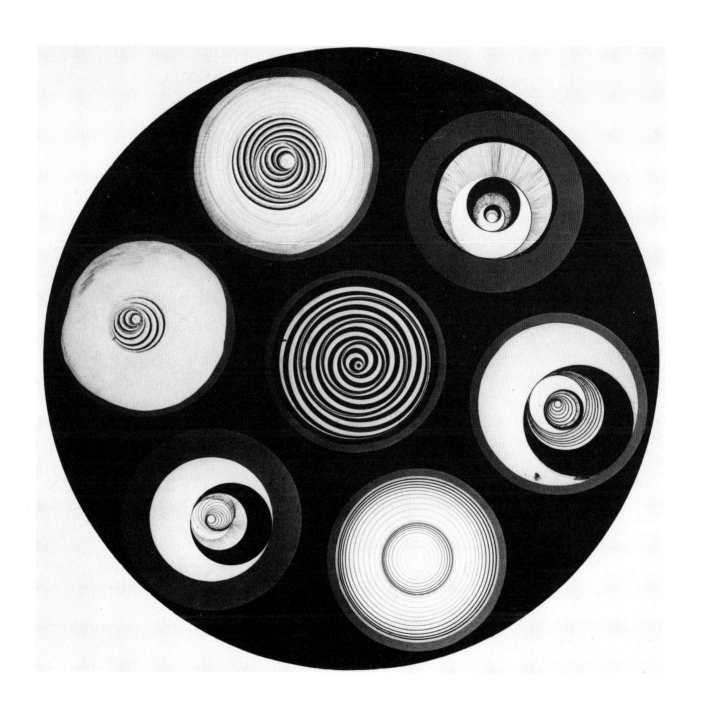

38 Duchamp, *Disks Bearing Spirals*. 1923

Man Ray

41 *Drawing.* 1915
Charcoal, 24⅝ x 19″
Collection The Museum of Modern Art,
New York. Mr. and Mrs. Donald B.
Straus Fund

42 *The Rope Dancer Accompanies Herself
with Her Shadows.* 1917
Aerograph (airbrushed gouache),
13⅜ x 17⅜″
Collection Mr. and Mrs. Morton Neumann

*43 *Admiration of the Orchestrelle for the
Cinematograph.* 1919
Aerograph (airbrushed gouache, wash
and ink), 26 x 21½″
Collection The Museum of Modern Art,
New York, Gift of A. Conger Goodyear

*44 *Jazz.* c. 1919
Aerograph (air brushed paint),
27¼ x 21¼″
The Columbus (Ohio) Gallery of Fine
Arts: Ferdinand Howald Collection

45 *Object to be Destroyed.* 1932
Ink, 11½ x 7¾″
Collection Mr. and Mrs. Morton Neumann

46 *Etude pour La Fortune.* 1938
Ink, 10¼ x 13¼″
Collection Whitney Museum of American
Art, New York, Gift of the Simon
Foundation

*47 *Espoirs et illusions optiques.* 1938
Ink, 15 x 11″
Collection Timothy Baum, New York

48 *Women in the Night (Femmes au fond
noir).* 1945
Watercolor, 23¼ x 17¾″
Collection Andrew J. Crispo, New York

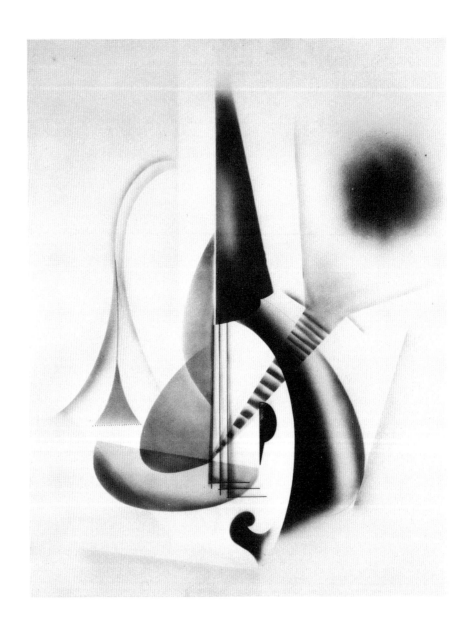

44 Man Ray, *Jazz.* c. 1919

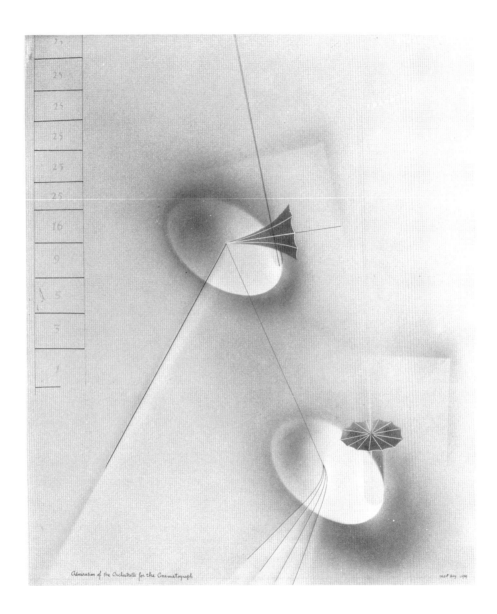

43 Man Ray, *Admiration of the Orchestrelle for the Cinematograph.* 1919

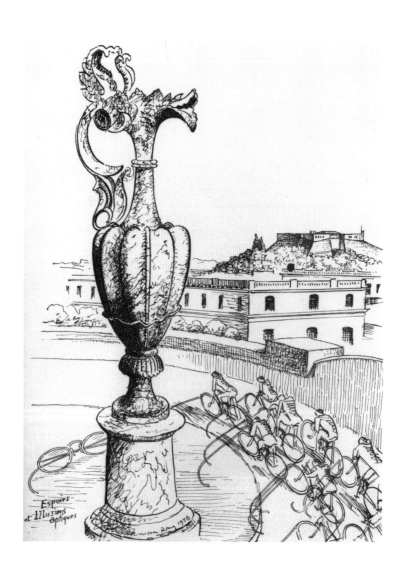

47 Man Ray, *Espoirs et illusions optiques*. 1938

Marsden Hartley

*49 *Military Symbol I.* c. 1913-14
Charcoal, 24¼ x 18¼″
Collection The Metropolitan Museum
of Art, New York, Rogers Fund, 1962

50 *Military Symbol II.* c. 1913-14
Charcoal, 24¼ x 18¼″
Collection The Metropolitan Museum
of Art, New York, Rogers Fund, 1962

51 *Military Symbol III.* c. 1913-14
Charcoal, 24¼ x 18¼″
Collection The Metropolitan Museum
of Art, New York, Rogers Fund, 1962

49 Hartley, *Military Symbol I.* c. 1913-14

Stanton Macdonald-Wright

*52 *Study for Conception Synchromy.* 1914
 Watercolor, 23 x 17½ "
 Collection Mr. and Mrs. Henry M. Reed

53 *A Synchromy.* 1914
 Gouache, 20¾ x 12¾ "
 Private Collection

54 *Guardian #8.* 1973
 Watercolor, 27¼ x 20½ "
 Collection Kay Hillman and Esther
 Robles

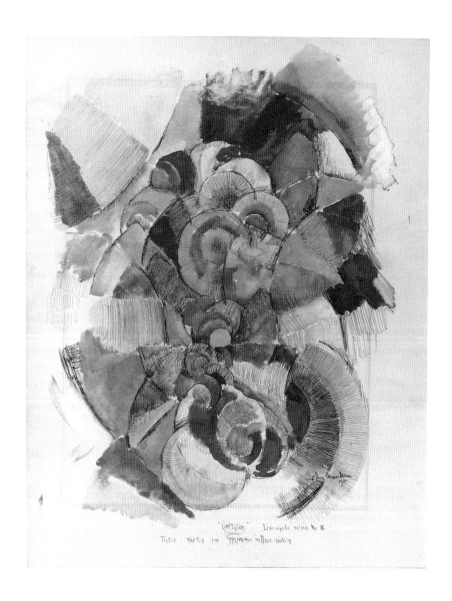

52 Macdonald-Wright, *Study for Conception Synchromy.* 1914

Morgan Russell

55 *Synchromism # 1*. c. 1913-14
Oil, 11⅜ x 10½″
Lent by Valley House Gallery,
Dallas

*56 *Synchromism # 2*. c. 1913-14
Oil, 12¾ x 16⅛″
Lent by Valley House Gallery,
Dallas

57 *Four Part Synchromy*. n.d.
Oil, four drawings on one sheet,
3⅞ x 15¾″ (sight)
Collection Mr. and Mrs. Henry M. Reed

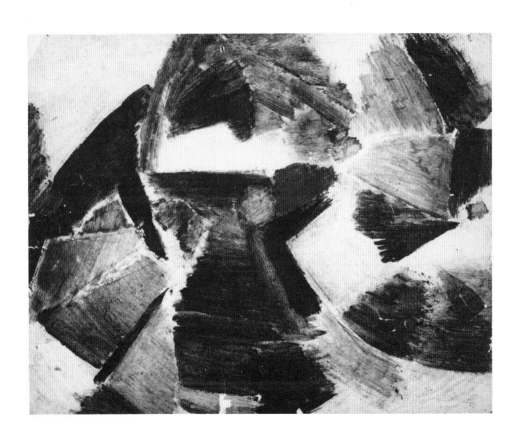

56 Russell, *Synchromism #2*. c. 1913-14

Stuart Davis

58 *Untitled (Greek).* 1921
Pencil and watercolor, 23 x 17¼"
Courtesy Mrs. Stuart Davis

59 *Untitled.* c. 1921
Pencil, ink and watercolor, 23 x 17⅜"
Courtesy Mrs. Stuart Davis

60 *Percolator.* 1927.
Tempera on paperboard, 14⅜ x 17¾"
Courtesy Mrs. Stuart Davis

*61 *Eggbeater #1.* 1927
Tempera on paperboard, 14½ x 18"
Courtesy Mrs. Stuart Davis

62 *Eggbeater #4.* 1928
Tempera on paperboard, 14 x 19⅜"
Courtesy Mrs. Stuart Davis

63 *Composition (1863).* c. 1930
Gouache, 20½ x 28"
Collection Mr. and Mrs. Burton Tremaine,
Meriden, Connecticut

*64 *Study for Barbershop Chord.* 1931
Crayon, 14 x 19"
Collection Mr. and Mrs. George K. Conant

*65 *Davits.* 1932
Ink, 20¾ x 28½"
Collection Fogg Art Museum, Harvard
University, Cambridge, Massachusetts,
Bequest of Meta and Paul J. Sachs

*66 *New York Waterfront.* 1938
Gouache, 12 x 15⅞"
Collection The Museum of Modern Art,
New York, Given anonymously

†67 *Study for Package Deal.* 1956
Gouache, 13½ x 11¾"
Private Collection

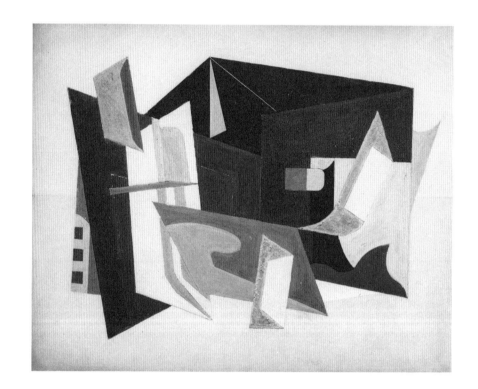

61 Davis, *Eggbeater #1.* 1927

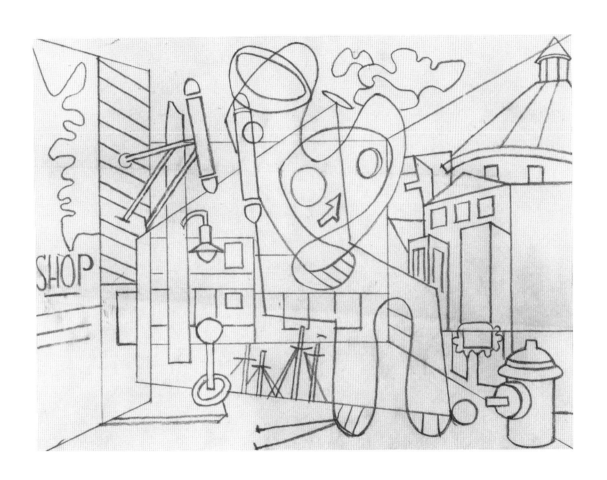

64 Davis, *Study for Barbershop Chord.* 1931

65 Davis, *Davits*. 1932

66 Davis, *New York Waterfront*. 1938

Josef Albers

68 *Structural Constellation.* 1956
Ink, 15⅞ x 12½"
Collection The Brooklyn Museum,
Dick S. Ramsay Fund

*69 *MM3.* 1961
Ink, 18⅛ x 23"
Collection The Museum of Modern Art,
New York, Gift of the artist

*70 *Reverse + Obverse.* 1962
Ink, 22¼ x 14"
Collection Whitney Museum of American
Art, New York, Gift under the Ford
Foundation Purchase Program

69 Albers, *MM3.* 1961

70 Albers, *Reverse* + *Obverse*. 1962

Hans Hofmann

71 *Untitled.* 1942
Crayon, 14 x 17″
Lent by André Emmerich Gallery, New
York

72 *Untitled Sketch.* 1943
Gouache, 17¾ x 23¾″
Lent by André Emmerich Gallery, New
York

*73 *Ambush.* 1944
Oil, 24 x 19″
Collection The Museum of Modern Art,
New York, Purchase

*74 *Untitled.* 1944
Ink and gouache, 17¾ x 24″
Collection Vals and Robert G. Osborne

75 *Construction,* 1948
Oil, 16¾ x 13¾″
Collection Whitney Museum of American
Art, New York

76 *Yellow and Red Still Life.* 1948
Oil, 17½ x 23½″
Collection Ferne Kandel Kolodner

77 *Oil on Paper III.* 1963
Oil, 8½ x 11″
Collection Sharon Percy Rockefeller

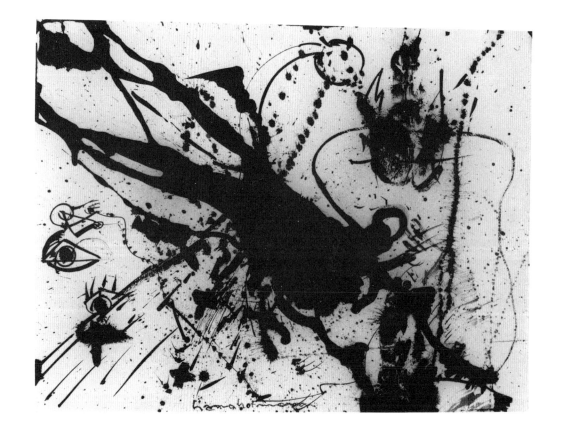

60 74 Hofmann, *Untitled.* 1944

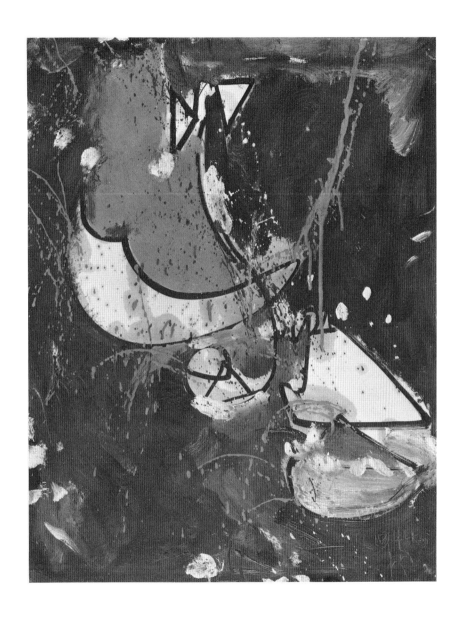

73 Albers, *Ambush*. 1944

Arshile Gorky

*78 *The Artist's Mother.* 1926
Charcoal, 24¾ x 19⅛″
The Art Institute of Chicago, The
Worcester Sketch Collection

*79 *Nighttime, Enigma and Nostalgia.*
c. 1929-34
Ink, 21⅝ x 28″
Lent by Fourcade, Droll Inc., New York

*80 *Composition.* 1943
Crayon and pencil, 22⅞ x 29″
Collection The Art Institute of Chicago,
Gift of The Ada Turnbull Hertle Fund;
Joseph Shapiro; Louis Silver; Peter
Bensinger; and Helen Regenstein

81 *Anatomical Blackboard.* 1943
Crayon and pencil, 20¼ x 27⅜″
Collection Mr. and Mrs. Walter Bareiss

82 *The Housatonic.* 1943
Ink and crayon, 19 x 24¾″
Private Collection

83 *Virginia Landscape.* 1943
Pastel and pencil, 19¾ x 26½″
Private Collection

84 *Carnival.* 1944
Pastel, 22 x 29⅞″
Collection Mario Tazzoli

*85 *Composition.* 1946
Ink, wash and crayon, 20 x 26¼″
Collection Mr. and Mrs. Stephen D.
Paine, Boston

86 *Untitled.* 1948
Pencil and crayon, 19½ x 26½″
Reis Family Collection

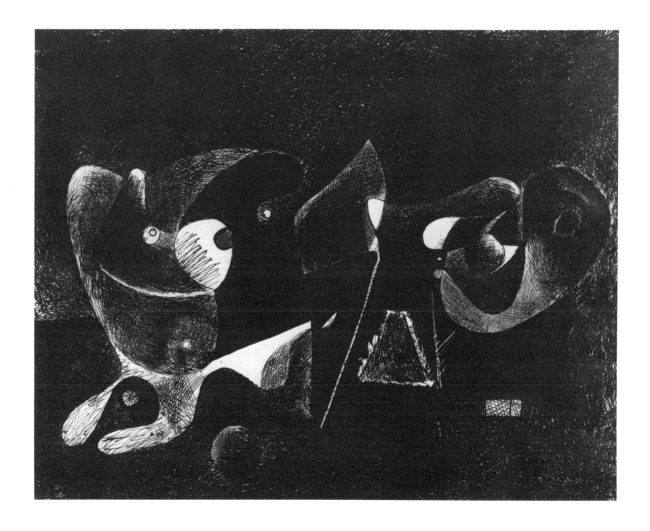

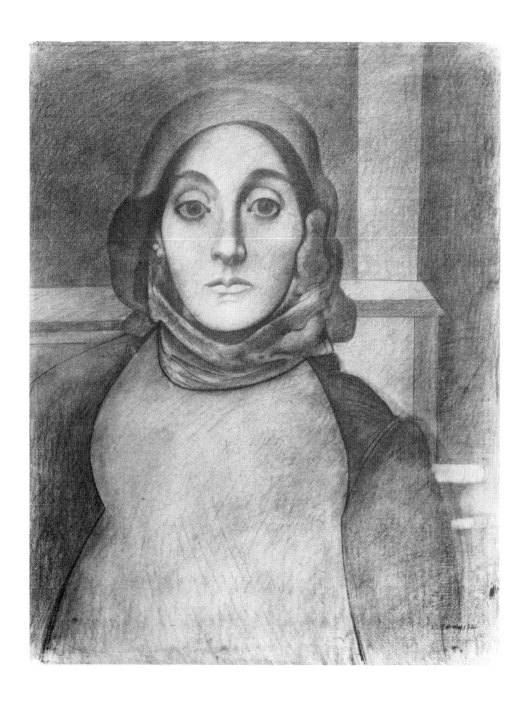

78 Gorky, *The Artist's Mother*. 1926

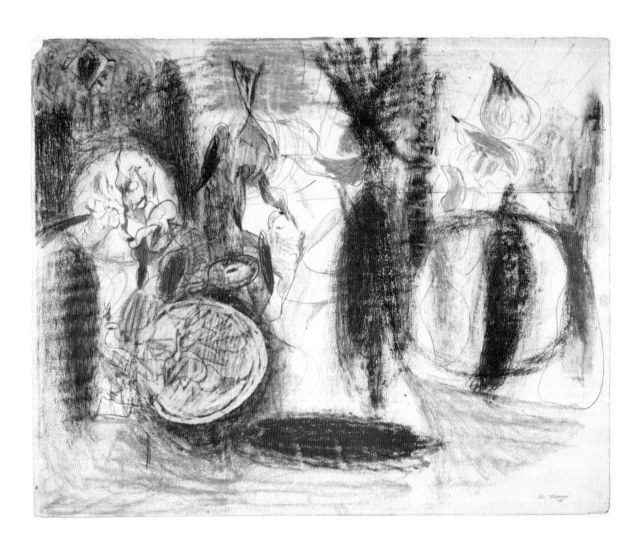

80 Gorky, *Composition*. 1943

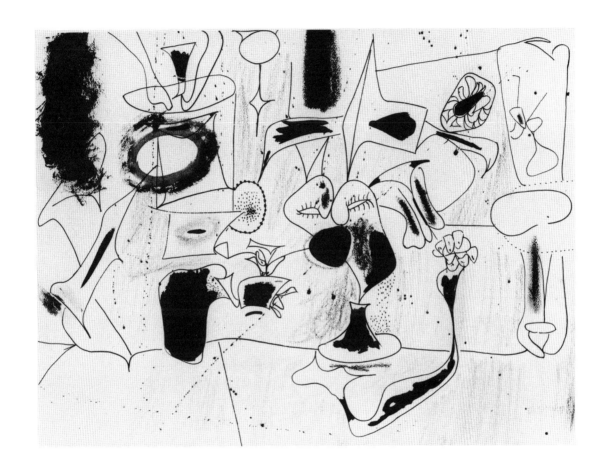

85 Gorky, *Composition*. 1946

Jackson Pollock

87 *Untitled.* 1943
Collage of paper with gouache and ink,
15⅞ x 21¼″
Private Collection

*88 *Untitled.* 1944
Ink, gouache, pastel, wash and sgraffito,
18¾ x 24¾″
Collection Dr. and Mrs. Martin L. Gecht,
Chicago

89 *Untitled.* 1945
Pastel, enamel and sgraffito,
25¾ x 20½″
Collection Mr. and Mrs. Walter Bareiss

†90 *Untitled.* Summer 1945
Ink and gouache over 1944 drypoint
engraving, 17 x 25″
Private Collection

91 *Number 14.* 1948
Enamel on wet gesso, 22¾ x 31″
Private Collection

92 *Number 12.* 1949
Enamel on paper mounted on composi-
tion board, 31 x 22½″
Collection The Museum of Modern Art,
New York, Gift of Edgar Kaufmann, Jr.

*93 *Number 34.* 1949
Enamel, aluminum paint on paper
mounted on composition board,
22 x 30½″
Collection Munson-Williams-Proctor
Institute, Utica, New York, Edward W.
Root Bequest

94 *Untitled.* 1951
Watercolor and ink, 24½ x 34″
Collection Jackson Friedman

*95 *Drawing.* 1953-54
Ink, 15¾ x 20½″
Collection The Museum of Modern Art,
New York, Gift of Mr. and Mrs. Ira Haupt

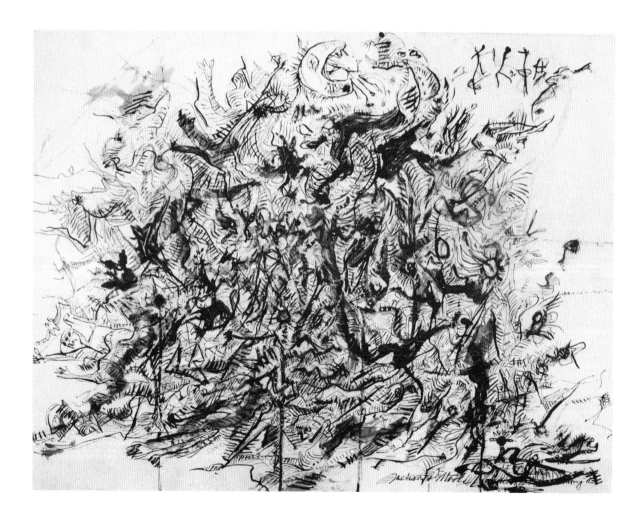

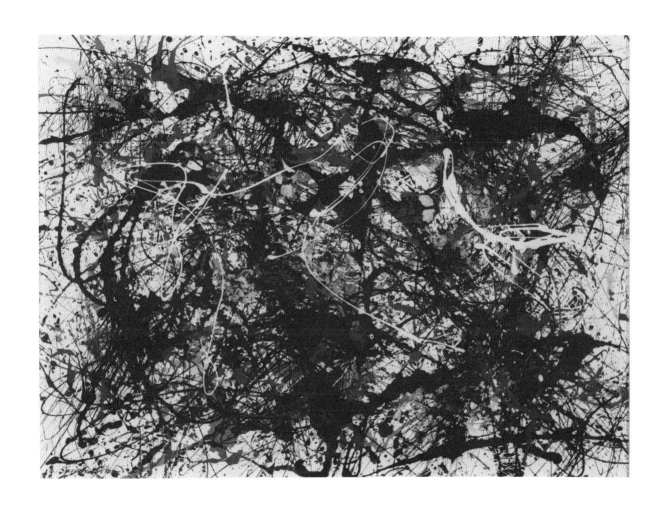

93 Pollock, *Number 34.* 1949

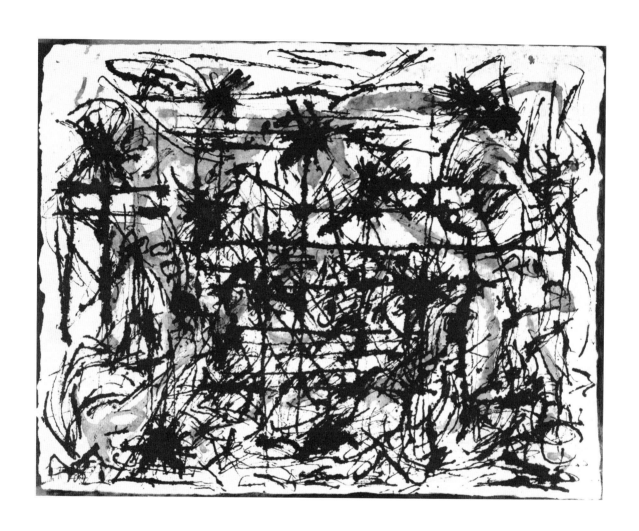

95 Pollock, *Drawing*. 1953-54

Willem de Kooning

96 *Working Man.* c. 1938
Pencil, 11 x 9″
Collection Max Margulis

*97 *Elaine de Kooning.* 1940
Pencil, 12¼ x 11⅞″
Collection Allan Stone

98 *Study of Woman.* 1942
Pencil, 7½ x 5″
Collection Allan Stone

99 *Abstraction.* c. 1945
Pencil, 18 x 23″
Collection Mr. and Mrs. Lee V. Eastman

*100 *Pink Lady.* c. 1948
Oil, 18½ x 18½″
Collection Mr. and Mrs. Donald Blinken

101 *Black and White Abstraction.* c. 1950-51
Sapolin enamel, 21¾ x 27⅞″
Lent by Fourcade, Droll Inc., New York

102 *Two Women.* 1952
Paint and pastel, 11½ x 13″
Collection Mr. and Mrs. Lee V. Eastman

103 *Woman.* 1952
Pastel and pencil, 20¾ x 14¼″
Collection Mr. and Mrs. Stephen D.
Paine, Boston

*104 *Two Women.* 1952
Pastel and charcoal, 15½ x 17½″
Private Collection

105 *Five Women.* c. 1952
Pencil, 17⅜ x 28⅞″
Private Collection

*106 *July 4, 1957.* 1957
Oil on cut and pasted paper, 26¾ x 22″
Collection Australian National Gallery,
Canberra

107 *Untitled.* 1963
Oil, 29 x 23″
Reis Family Collection

108 *Untitled.* 1967
Charcoal, 18¾ x 24″
Collection The Museum of Modern Art,
New York, Gift of the artist

†109 *Untitled (Figure in Landscape).* 1974
Charcoal and pastel, 29¾ x 30½″
Collection Australian National Gallery,
Canberra

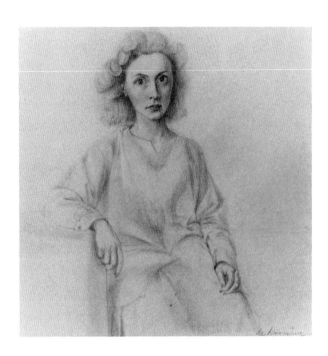

97 de Kooning, *Elaine de Kooning.* 1940

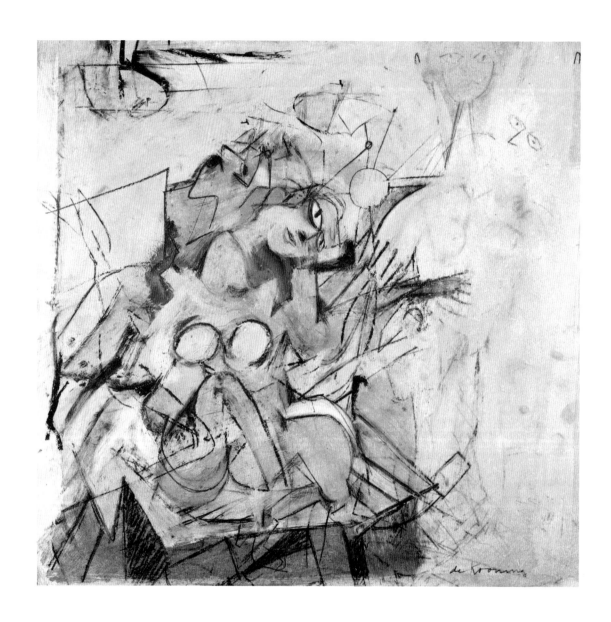

100 de Kooning, *Pink Lady*. c. 1948

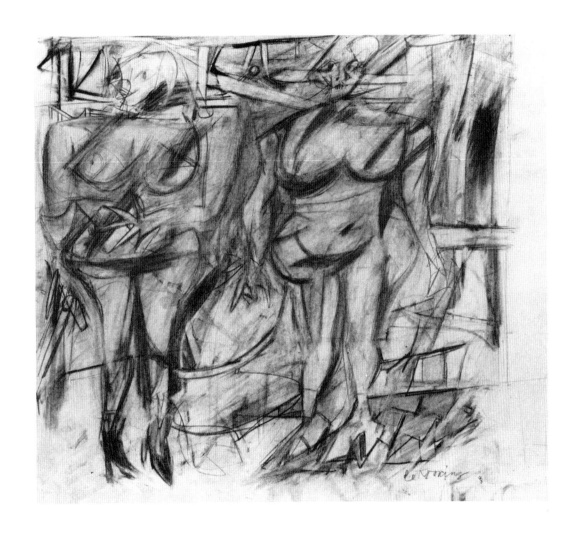

104 de Kooning, *Two Women*. 1952



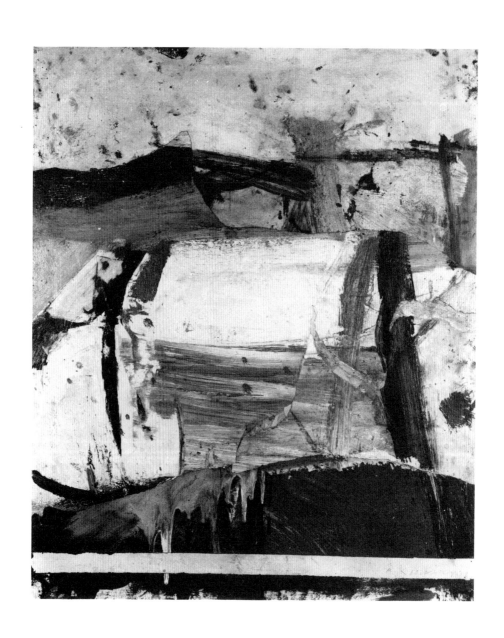

106 de Kooning, *July 4, 1957*. 1957

Franz Kline

110 *Nijinsky.* 1947
Pastel and ink, 11¼ x 8½"
Collection Mr. and Mrs. I. David Orr

111 *Untitled.* 1950
Collage of paper with oil, 27⅜ x 17⅞"
Private Collection

112 *Study for "The Cardinal."* 1950
Paint, 7⅞ x 5⅞"
Collection Mr. and Mrs. Lee V. Eastman

*113 *Rocker.* 1951
Oil, 17 x 14"
Collection Dr. and Mrs. Theodore J.
Edlich, Jr.

*114 *Study for Clockface.* c. 1951
Gouache on telephone book page,
11½ x 9½"
Collection Dr. and Mrs. Theodore J.
Edlich, Jr.

*115 *Untitled.* 1951
Ink, 6½ x 8¼"
Collection Mrs. R. B. Schulhof

116 *Black and White.* n.d.
Oil, 12½ x 10"
Contemporary Collection of The
Cleveland Museum of Art

*117 *Untitled.* n.d.
Ink, 16⅞ x 15½"
Reis Family Collection

118 *Red and Orange.* 1956
Oil, 23½ x 18½"
Courtesy David McKee, Inc., New York

119 *Untitled.* 1957
Collage of paper with oil, 8½ x 10⅞"
Private Collection

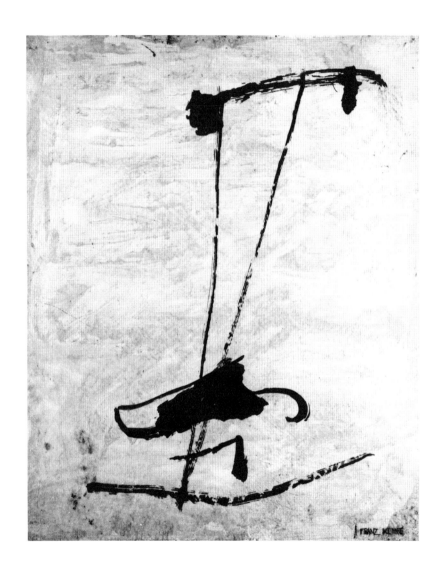

113 Kline, *Rocker.* 1951

73

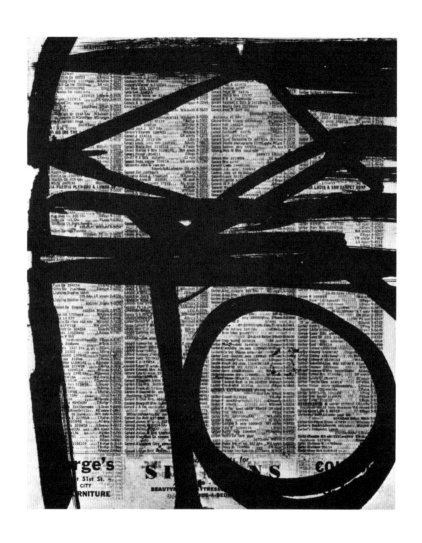

114 Kline, *Study for Clockface.* c. 1951

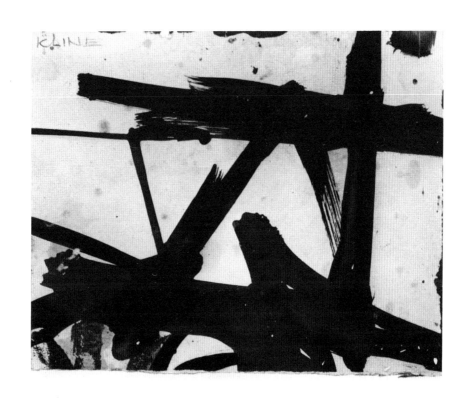

115 Kline, *Untitled.* 1951

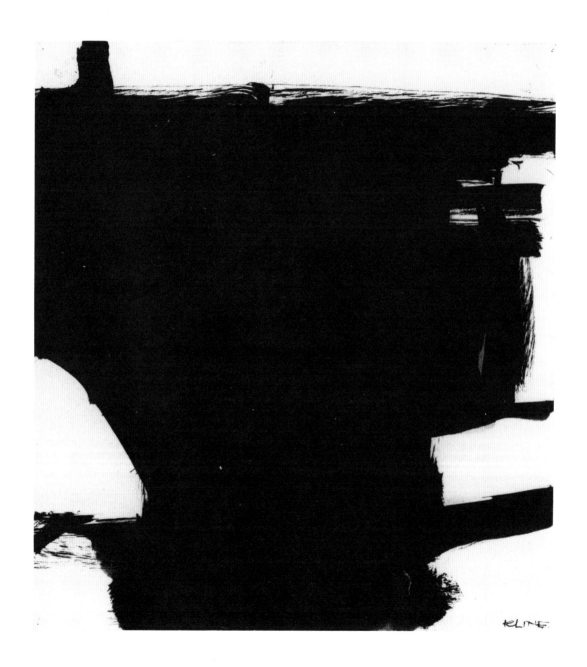

117 Kline, *Untitled*. n.d.

Mark Rothko

120 *Prehistoric Memory.* 1946
 Pastel, 25¾ x 19⅜"
 Collection Steingrim Laursen,
 Copenhagen

*121 *Untitled.* 1946
 Watercolor, 38¾ x 25½"
 Collection Mr. and Mrs. Donald Blinken

122 *Vessels of Magic.* 1947
 Watercolor, 38¾ x 25¾"
 Collection The Brooklyn Museum

*123 *No. 47.* 1957
 Tempera on paper mounted on
 masonite, 27¾ x 24¾"
 Reis Family Collection

124 *Brown, Maroon, Rust on Plum.* 1959
 Tempera on paper mounted on
 masonite, 37¾ x 25"
 Reis Family Collection

*125 *Red.* 1968
 Oil on paper mounted on canvas,
 33 x 25¾"
 Collection Mrs. R. B. Schulhof

126 *Untitled.* 1968
 Tempera on paper mounted on
 masonite, 39¼ x 26"
 Reis Family Collection

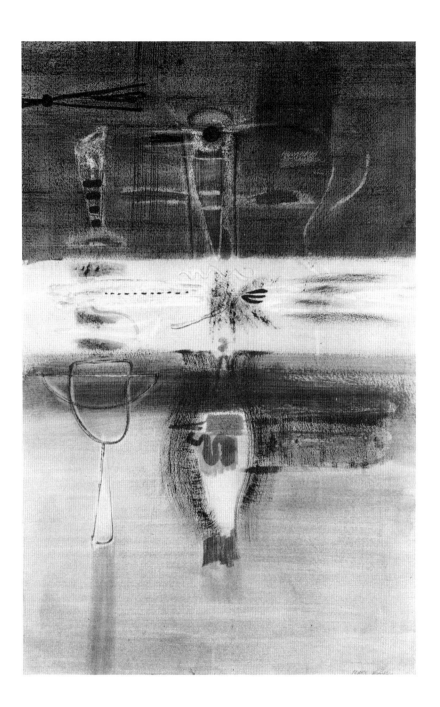

121 Rothko, *Untitled.* 1946

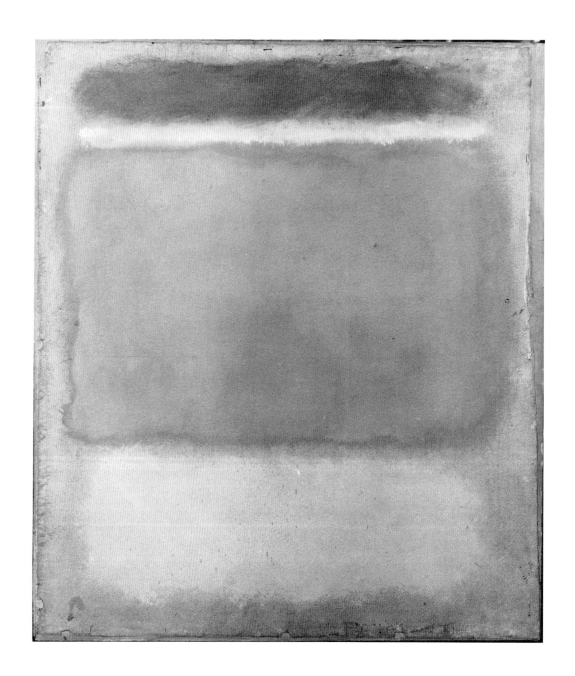

123 Rothko, *No. 47*. 1957

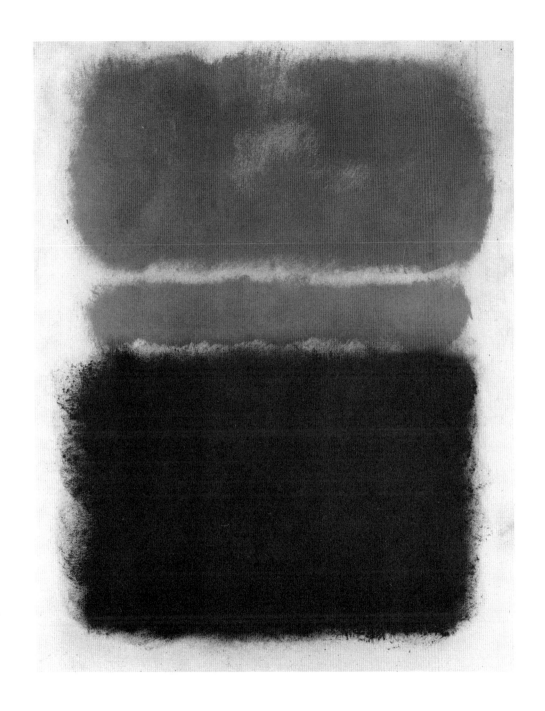

125 Rothko, *Red*. 1968

Clyfford Still

*127 *1944.* 1944
 Oil, 25½ x 15¼"
 Lent by Marlborough Gallery, New York

*128 *1948.* 1948
 Gouache, 30 x 22"
 Collection Mrs. Lloyd Bruce Wescott

*129 *1949.* 1949
 Gouache, 17½ x 22"
 Reis Family Collection

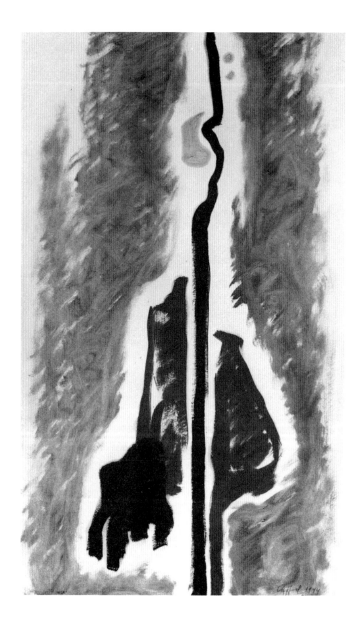

127 Still, *1944.* 1944

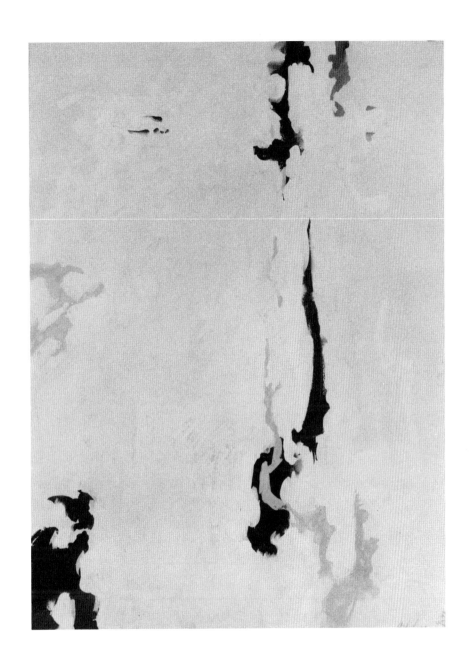

128 Still, *1948*. 1948

82 129 Still, *1949*. 1949

Barnett Newman

130 *The Blessing.* 1944
Oil and oil crayon, 25½ x 19″
Collection Annalee Newman

*131 *Drawing.* 1945
Ink, 11 x 7½″
Collection Annalee Newman

*132 *Drawing.* 1946
Ink, 23¾ x 17¾″
Collection Annalee Newman

133 *Drawing.* 1946
Ink, 24 x 18″
Collection Annalee Newman

134 *Drawing.* 1946
Ink, 36 x 24″
Collection Annalee Newman

135 *Untitled (Onement I).* 1947
Ink, 10⅞ x 7⅜″
Collection Mr. and Mrs. B. H. Friedman

*136 *Drawing No. 13.* 1960
Ink, 14 x 10″
Collection Annalee Newman

137 *Drawing No. 14.* 1960
Ink, 14 x 10″
Collection Mr. and Mrs. Ben Heller

*138 *Drawing.* 1969
Ink, 60 x 42″
Collection Annalee Newman

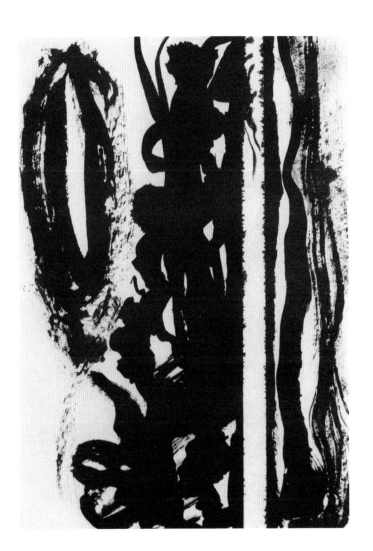

131 Newman, *Drawing.* 1945

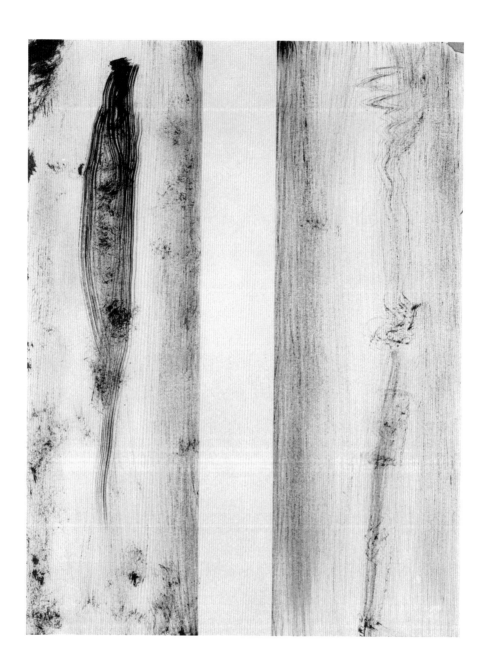

132 Newman, *Drawing*. 1946

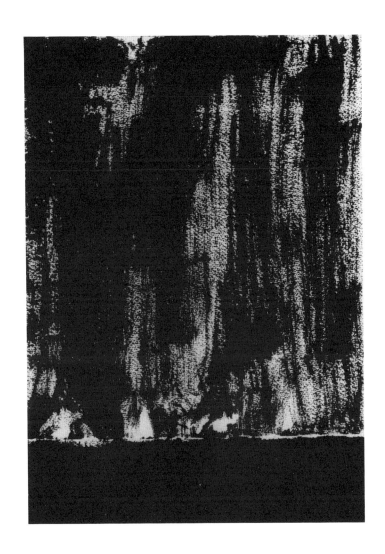

136 Newman, *Drawing No. 13*. 1960

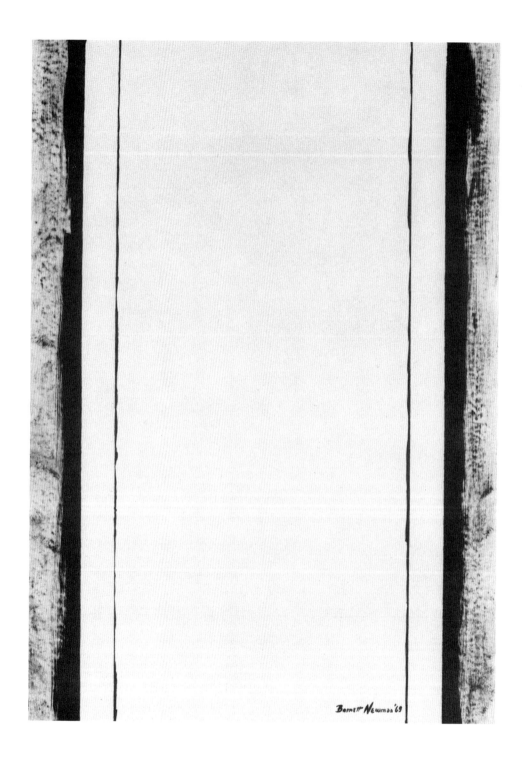

138 Newman, *Drawing*. 1969

Robert Motherwell

139 *Joy of Living.* 1943
Collage of paper and map with ink,
tempera and crayon on paperboard,
43½ x 35¼″
The Baltimore Museum of Art, The Saidie
A. May Collection

*140 *Figure.* 1945
Collage of paper and tape with gouache
on paperboard, 44¾ x 24½″
Private Collection

141 *In Grey with Parasol.* 1946
Collage of paper with oil on paperboard,
47½ x 35½″ (sight)
Collection Art Gallery of Ontario,
Toronto, Gift from the Women's
Committee Fund, 1962

142 *At Five in the Afternoon.* 1949
Casein on paperboard, 15 x 20″
Collection Helen Frankenthaler

143 *Madrid #4.* 1958
Charcoal, 25 x 33″
Collection Mr. and Mrs. Lee V. Eastman

144 *The French Line.* 1960
Collage, 30 x 23″
Collection Mr. and Mrs. Bagley Wright

145 *Pyrenean Collage.* 1961
Collage of paper with oil, 23 x 29″
Collection Helen Frankenthaler

*146 *Beside the Sea, No. 3.* 1962
Oil, 28¾ x 22¾″
Collection Mrs. R. B. Schulhof

*147 *The Baltic Sea Bride, No. IV.* 1974
Collage of paper envelope on Vepson
board, 48 x 36″
Collection Andrew J. Crispo, New York

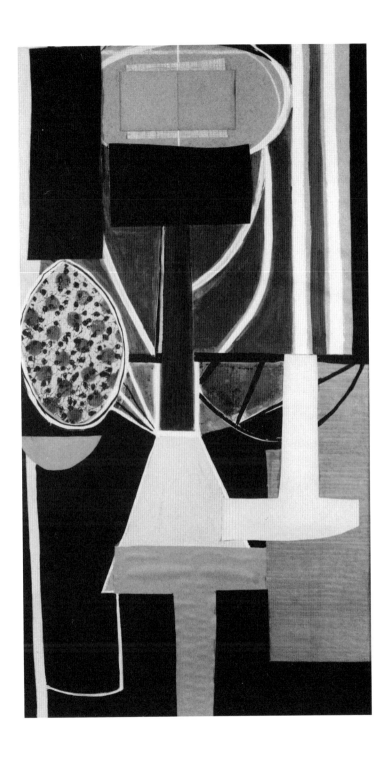

140 Motherwell, *Figure.* 1945

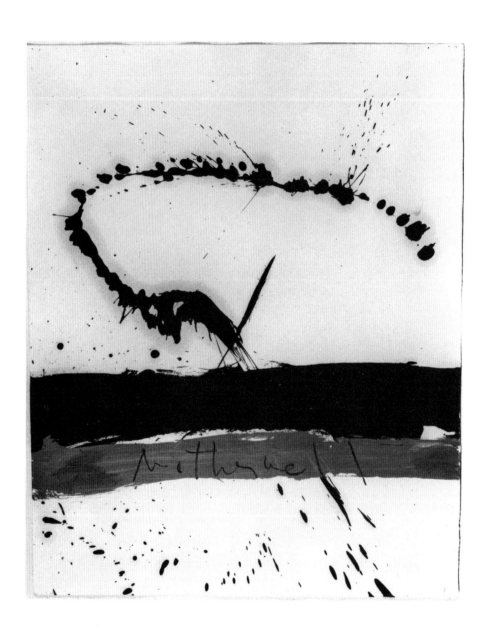

146 Motherwell, *Beside the Sea, No. 3.* 1962

147 Motherwell, *The Baltic Sea Bride, No. IV.* 1974

Joseph Cornell

*148 *Untitled.* 1931
 Collage of etching and paper on
 paperboard, 4½ x 5¾″
 Collection June W. Schuster, Pasadena

 149 *Story Without a Name for Max Ernst.*
 c. 1937
 Collage of reproductions on paperboard,
 13 x 19″
 Private Collection

*150 *The Sisters Shades.* 1956
 Collage of photographs and reproduc-
 tions on paperboard, 12 x 9″
 Lent by Fourcade, Droll Inc., New York

*151 *Cassiopeia.* 1963
 Collage of reproduction, gouache ? and
 watercolor, 11½ x 8½″
 Collection Mr. and Mrs. E. A. Bergman

 152 *Interplanetary Navigation.* 1964
 Collage of paper, magazine illustrations
 with watercolor, 11⅜ x 8½″
 Collection The Solomon R. Guggenheim
 Museum, New York, Gift of Mr. and Mrs.
 Walter N. Pharr

 153 *Cassiopeia.* 1966
 Collage of reproduction with oil,
 9 x 11¾″
 Collection Mr. and Mrs. E. A. Bergman

 154 *Now Voyager.* 1966
 Collage of photograph and reproduction
 with paint, 11¼ x 8¼″
 Collection Mr. and Mrs. E. A. Bergman

148 Cornell, *Untitled.* 1931

150 Cornell, *The Sisters Shades.* 1956

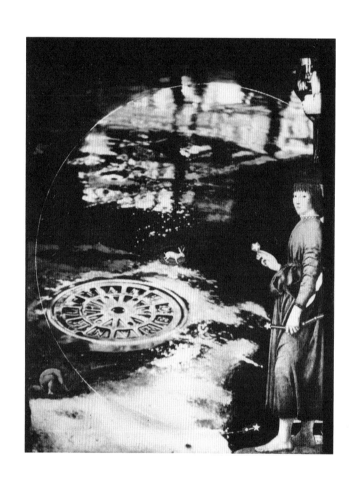

151 Cornell, *Cassiopeia*. 1963

Robert Rauschenberg

155 *Aeroplane.* 1958
Pencil and watercolor, 24 x 36″
Collection Mr. and Mrs. Victor W. Ganz

*156 *Untitled.* 1961
Combine drawing of transfer, gouache,
watercolor, pencil and crayon,
14½ x 23″
Collection Mr. and Mrs. Leo Castelli

157 *Site for Love.* 1963
Combine drawing of transfer, water-
color, ink, wash and pencil on canvas,
30 x 40″
Collection Mr. and Mrs. Victor W. Ganz

158 *Dante's Inferno: Drawings for Dante's
700th Birthday (Life Lay-Out).* 1965
Collage of magazine clippings and
photographs with ink, crayon and pencil,
two panels, each 15 x 13½″
Collection Mr. and Mrs. Victor W. Ganz

*159 *Untitled.* 1968
Combine drawing of transfer, gouache,
watercolor, pencil and crayon,
22½ x 30″
Collection Mr. and Mrs. Leo Castelli

160 *Untitled.* 1968
Combine drawing of transfer, watercolor,
ink, wash and pencil, 22½ x 30″
Collection Mr. and Mrs. Victor W. Ganz

161 *Combine Drawing.* 1973
Collage of paper bags with
pencil, 49¾ x 60⅛″
Collection Roy and Dorothy Lichtenstein

162 *Untitled.* 1973
Collage of mat transfer, gauze and paper
bag, 60 x 72″
Collection Robert Rauschenberg

156 Rauschenberg, *Untitled.* 1961

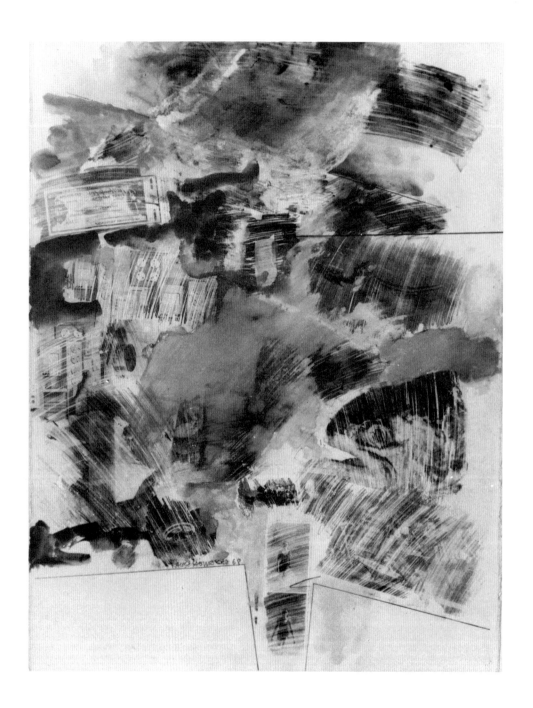

159 Rauschenberg, *Untitled*. 1968

Jasper Johns

*163 *Target with Four Faces.* 1955
Pencil, 8½ x 7¼″
Lent by the artist

164 *Flag.* 1957
Pencil, 10¾ x 15½″
Lent by the artist

*165 *Tennyson.* 1958
Ink, 14⅞ x 9⅞″
Lent by the artist

166 *Two Flags.* 1960
Graphite wash, 29½ x 21¾″
Lent by the artist

167 *Out the Window.* 1960
Charcoal and pastel, 34½ x 28½″
Collection Dr. and Mrs. Bernard Brodsky

*168 *Numbers.* 1960
Graphite, wash and gouache?,
20⅝ x 18″
Collection Mr. and Mrs. Stephen D.
Paine, Boston

169 *Thermometer.* 1960
Charcoal and pastel, 22¼ x 16½″
Lent by the artist

170 *0-9.* 1960
Pencil, ten drawings in one frame, each
2¾ x 2¼″
Private Collection

171 *Device.* 1962
Ink on polyester film, 21 x 15½″
Collection Mr. and Mrs. Leo Castelli

172 *Watchman.* 1966
Metallic powder, graphite and pastel,
38 x 26½″
Collection Mr. and Mrs. Victor W. Ganz

173 *Zone.* 1969
Graphite, chalk and tempera, 37 x 26″
Lent by the artist

174 *Untitled.* 1973
Charcoal, 41¼ x 29½″
Collection Roger Davidson

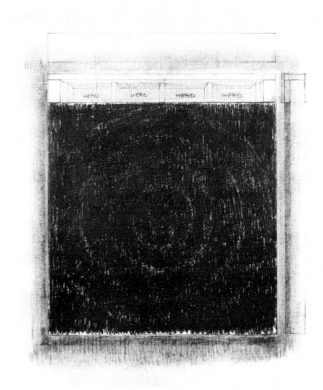

163 Johns, *Target with Four Faces.* 1955

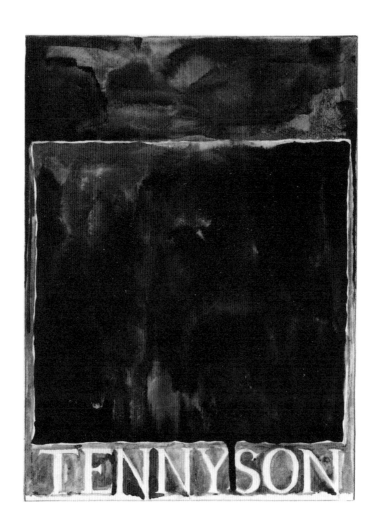

165 Johns, *Tennyson*. 1958

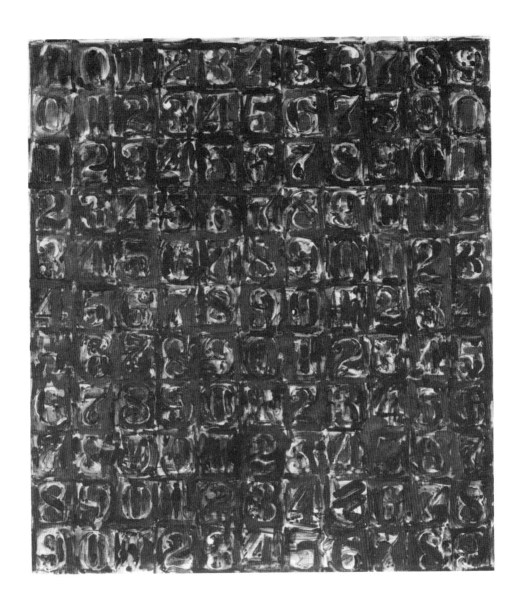

168 Johns, *Numbers*. 1960

Cy Twombly

175 *Untitled*. 1953
Pencil, 21¾ x 29¾"
Collection John Bedenkapp

176 *Untitled*. 1959 and 1963
Pencil, ink and crayon, 19¾ x 27½"
Collection Mr. and Mrs. Leo Castelli

177 *Untitled*. 1964
Crayon and pencil, 27½ x 39½"
Collection Roy and Dorothy Lichtenstein

178 *Untitled*. 1965
Pencil and crayon, 26½ x 34"
Private Collection

*179 *Untitled*. 1969
Oil and crayon, 30 x 40"
Collection Mr. and Mrs. Leo Castelli

*180 *Untitled*. 1971
Collage, pencil and crayon, 22½ x 30¾"
Collection Mr. and Mrs. Leo Castelli

181 *Untitled, January 1974*. 1974
Collage, pencil and crayon, 30 x 22⅜"
Lent by Leo Castelli Gallery, New York

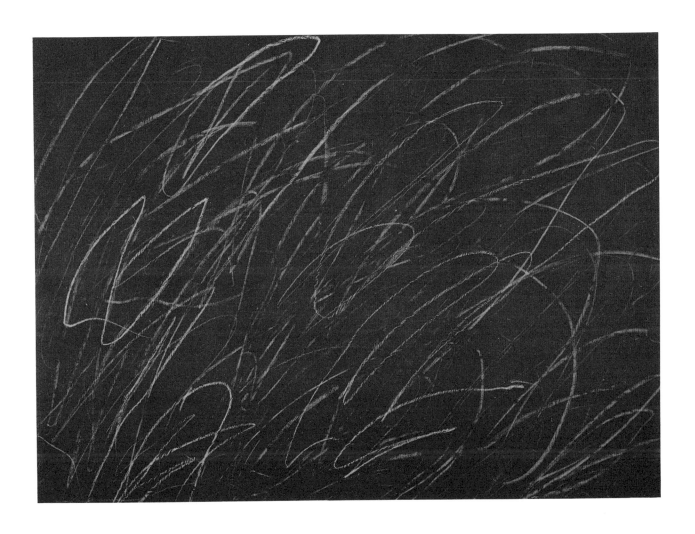

180 Twombly, *Untitled.* 1971

Ellsworth Kelly

†182 *Color Strips Arranged by Chance.* 1951
Collage of paper, 19½ x 34¾ ″
Private Collection

*183 *Study for Cité; Brushstrokes Cut into Twenty Squares and Arranged by Chance.* 1951
Collage of ink drawings on paper, 12¼ x 15⅛ ″
Private Collection

184 *Spectrum Colors Arranged by Chance.* 1951
Collage of paper, 39 x 39″
Private Collection

185 *Four Blacks.* 1952
Collage of paper, 8½ x 16½ ″
Private Collection

186 *Kite Study.* 1952
Collage of paper, 11 x 9½ ″
Private Collection

187 *Three Strokes.* 1962
Pencil, 28½ x 22½ ″
Private Collection

*188 *One Stroke.* 1962
Pencil, 28½ x 22½ ″
Collection The Solomon R. Guggenheim Museum, New York, Gift of The School of Visual Arts, 1971

189 *Capri.* 1964
Collage of color lithograph proofs on postcard, 4 x 5¾ ″
Private Collection

190 *Water Lily Leaf.* 1968
Pencil, 29 x 23″
Private Collection

191 *Untitled.* 1974
Pencil, 46 x 40″
Lent by Leo Castelli Gallery, New York

100 183 Kelly, *Study for Cité; Brushstrokes Cut into Twenty Squares and Arranged by Chance.* 1951

188 Kelly, *One Stroke*. 1962

Roy Lichtenstein

*192 *Bratatat!* 1962
Pencil and pencil frottage, 20½ x 16¼"
Collection The Minneapolis Institute of
Arts, the Ethel Morrison Van Derlip Fund

193 *Shock-proof.* 1963
Pencil and touche, 30 x 22½"
Collection Mr. and Mrs. Leo Castelli

194 *Diana.* 1965
Pencil and touche, 29¾ x 22¼"
Collection Mrs. Leo Castelli

*195 *Brushstrokes.* 1966-68
Pencil, 22¼ x 30"
Collection Mr. and Mrs. Leo Castelli

196 *Study for Preparedness.* 1968
Pencil and colored pencil, 17½ x 25½"
Private Collection

*197 *Mirror IV.* 1970
Collage of magna, silkscreen and tape
on paper mounted on paper,
34½ x 29⅝"
Private Collection

198 *Entablature.* 1971
Oil and pencil, 21 x 72"
Private Collection

199 *Studio IV.* 1974
Pencil and colored pencil, 20½ x 26"
Private Collection

*200 *Carlo Carra "The Red Horseman" 1913.*
1974
Pencil and colored pencil, 20¾ x 26"
Private Collection, New York

192 Lichtenstein, *Bratatat!* 1962

195 Lichtenstein, *Brushstrokes*. 1966-68

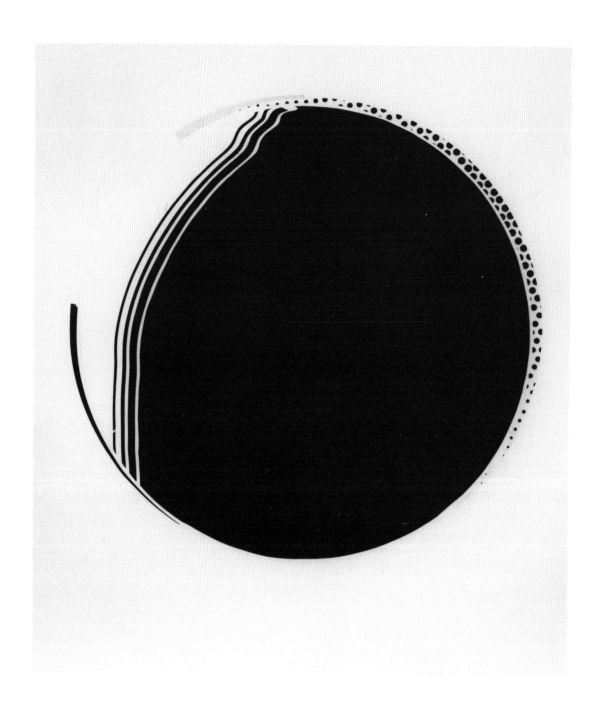

197 Lichtenstein, *Mirror IV*. 1970

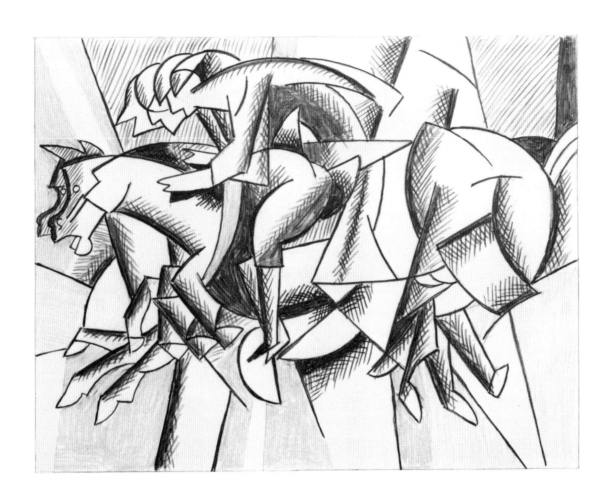

200 Lichtenstein, *Carlo Carra "The Red Horseman" 1913*. 1974

Claes Oldenburg

201 *Van.* 1960
Collage of paperboard with oil wash on
wood, 12¼ x 13″
Collection Patty Oldenburg

202 *Visualization of a Giant Soft Sculpture
in the Form of a Shirt with Tie.* 1963
Crayon and watercolor, 14 x 16½″
Collection Mr. and Mrs. Michael
Blankfort

203 *Plan for a Sculpture in the Form of Wall
Switches.* 1964
Ink and crayon, 28⅝ x 23⅜″
Collection Whitney Museum of American
Art, New York; Neysa McMein
Purchase Award

204 *Profile Study of the Airflow.* 1965
Collage of paper with pencil and
watercolor, 22 x 29¾″
Harry N. Abrams Family Collection

*205 *Proposed Colossal Monument for Park
Avenue, N.Y.C. — Good Humor Bar.* 1965
Crayon and watercolor, 23½ x 17½″
Collection Carroll Janis

206 *Proposed Monument for the Intersection
of Canal Street and Broadway, New
York: Block of Concrete Inscribed with
the Names of War Heroes.* 1965
Watercolor and crayon, 16 x 12″
Collection Alicia Legg, New York

*207 *Proposed Colossal Monument for
Thames River — Thames Ball Cock.* 1967
Crayon, ink and watercolor on postcard,
3½ x 5½″
Collection Carroll Janis

*208 *Study for a Heroic Monument in the
Form of a Bent Typewriter Eraser.* 1970
Pencil, graphite stick and erasure,
14½ x 11½″
Collection Mrs. R. B. Schulhof

209 *Alphabet as Good Humor Bar.* 1970
Pencil and colored crayon, 28½ x 22½″
Private Collection

210 *Proposal for a Colossal Monument in the
Form of Butter in a Baked Potato.* 1975
Crayon and watercolor, 26 x 40½″
Private Collection

207 Oldenburg, *Proposed Colossal Monument for Thames River — Thames Ball Cock.* 1967

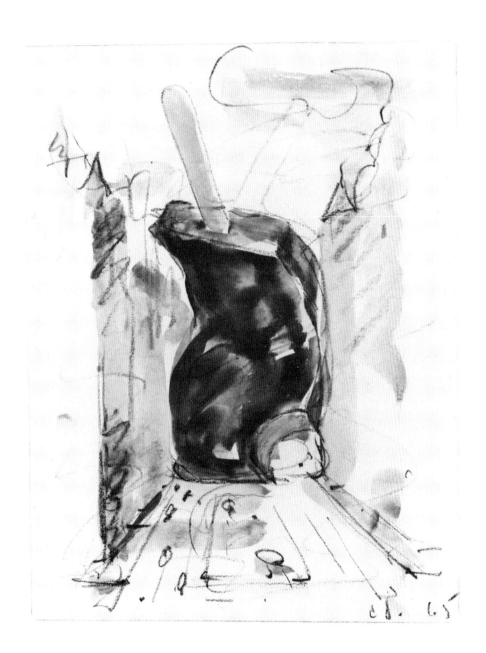

205 Oldenburg, *Proposed Colossal Monument for Park Avenue, N.Y.C.— Good Humor Bar.* 1965

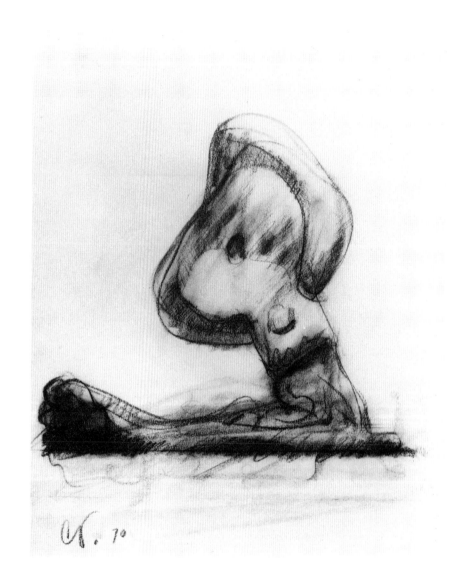

208 Oldenburg, *Study for a Heroic Monument in the Form of a Bent Typewriter Eraser*. 1970

Andy Warhol

211 *Dollar Bill.* 1961
Pencil, 30 x 40″
Collection Roy and Dorothy Lichtenstein

212 *Ginger Rogers.* 1962
Pencil, 24 x 18″
Lent by Locksley Shea Gallery,
Minneapolis

*213 *Campbell Soup Can with Catsup Bottle.*
1962
Pencil, 24 x 18″
Lent by Locksley Shea Gallery,
Minneapolis

*214 *One Dollar.* 1962
Pencil, 18 x 24″
Collection Mr. and Mrs. Peter M. Brant

215 *Soup Cans.* 1962
Pencil, 23⅝ x 18″
Collection Mr. and Mrs. Peter M. Brant

*216 *Mao.* 1973
Pencil, 33⅞ x 24″
Lent by Mitchell, Hutchins, Inc.

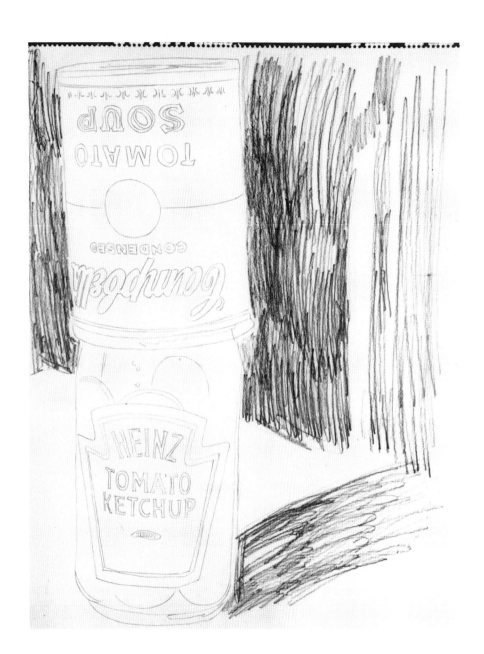

213 Warhol, *Campbell Soup Can with Catsup Bottle.* 1962

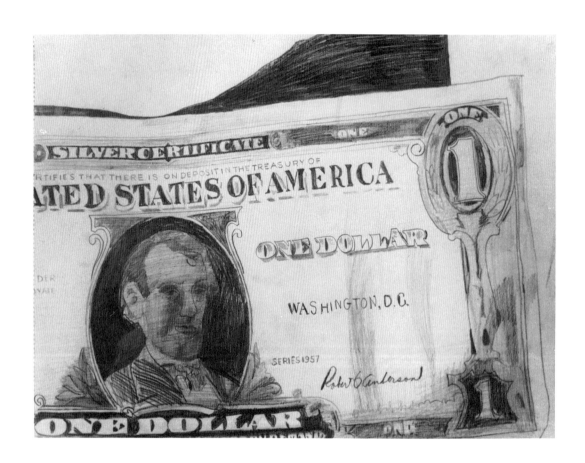

214 Warhol, *One Dollar*. 1962

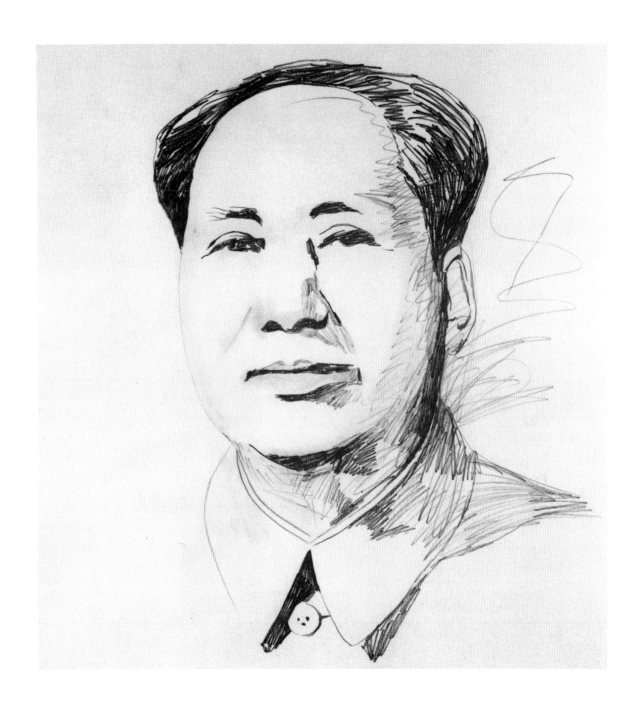

216　Warhol, *Mao.* 1973

Frank Stella

*217 *The First Post Cubist Collage.* 1959
 Ink on asbestos tape on paperboard,
 20¼ x 20¼"
 Yale University Art Gallery, New Haven,
 Lent by Richard Brown Baker, B.A. 1935

218 *Marriage of Reason and Squalor (Blue
 Sketch).* 1962
 Pencil and magic marker, 17 x 22"
 Courtesy Mr. Lawrence Rubin

*219 *Tuftonboro.* 1966
 Ink and watercolor on graph paper,
 17 x 22"
 Collection Mrs. R. B. Schulhof

220 *Effingham.* 1966
 Ink on graph paper, 17⅛ x 22"
 Collection Mr. and Mrs. Leo Castelli

221 *Untitled.* 1967-69
 Colored ink and pencil on graph paper,
 33⅛ x 53"
 Collection Mr. and Mrs. Kenneth Tyler

222 *Pastel Stack.* 1970
 Gouache and mixed media, 42¼ x 32"
 Courtesy Mr. Lawrence Rubin

223 *Felsztyn.* 1973
 Collage, 31⅜ x 26⅞"
 Collection Roger Davidson

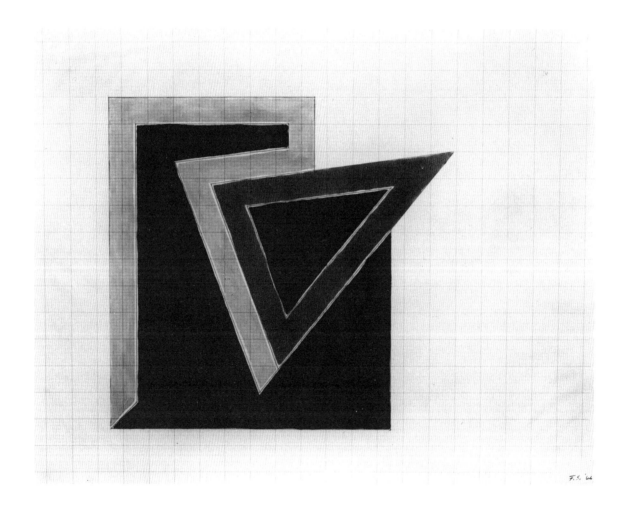

217 Stella, *The First Post Cubist Collage.* 1959

Josef Albers
b. 1888
Born in Bottrop, Westphalia, Germany. Studies 1913-20 in Berlin, Essen, Munich, then at Bauhaus, Weimar. 1923 becomes Bauhaus professor; teaches fundamental design, drawing and lettering and in glass and furniture workshops at the school in Weimar, Dessau and Berlin. 1933, upon closing of Bauhaus, moves to United States; heads art department at Black Mountain College, Black Mountain, North Carolina, until 1949. To Art School, Yale University, New Haven, 1949; 1950-58 chairman of Department of Design there; remains visiting professor until 1960. 1949 begins series *Homage to the Square.* Now retired from teaching, works and lives in Orange, Connecticut.

> Josef Albers, *Poems and Drawings: Gedichte und Zeichnungen,* New Haven, 1958; revised and enlarged, 1961
>
> François Bucher, *Despite Straight Lines: An Analysis of his Graphic Construction,* New Haven and London, 1961; contributions by the artist
>
> Eugen Gomringer, *Josef Albers,* New York, 1968; additional texts by Clara Diament de Sujo, Will Grohmann, Norbert Lynton and Michel Seuphor
>
> Werner Spies, *Albers,* New York, 1970

Joseph Cornell
1903-1972
Born in Nyack, New York. Attends Phillips Academy, Andover, Massachusetts. 1929 moves with his family to Flushing, New York, where he lives until his death. Largely self-taught; absorbs much from contact with European expatriate Surrealist painters and writers before and during World War II. First collages included in Surrealist group show at Julien Levy Gallery, New York, 1932. 1939 first one-man exhibition, Julien Levy Gallery. Throughout his career concentrates primarily on constructions but intermittently produces collages, especially during the 1960's.

> The Solomon R. Guggenheim Museum, New York, May 4-June 25, 1967, *Joseph Cornell*; cat. text by Diane Waldman
>
> Hilton Kramer, "Joseph Cornell's Baudelairean Voyage," *The New York Times,* Section 2, December 20, 1970, p. 27
>
> John Bernard Myers, "Cornell: The Enchanted Wanderer," *Art in America,* vol. 61, no. 5, September-October 1973, pp. 76-81
>
> Dore Ashton, *A Joseph Cornell Album,* New York, 1974

Stuart Davis
1894-1964
Born in Philadelphia. To East Orange, New Jersey, 1901. Through parents, both of whom were involved with art, early contact with artists including Sloan, Luks, Henri. Leaves high school after one year for study with Henri in New York, starting 1909. Exhibits watercolors at Armory Show, New York, 1913; intensely impressed by European art he sees there. Contact with Demuth, summer 1913, Provincetown, important to his development. Settles in New York, fall 1913; begins drawings and covers for *The Masses,* cartoons for *Harper's Weekly.* First one-man exhibition, Sheridan Square Gallery, New York, 1917; 1927 first of many shows at Downtown Gallery, New York. 1928-29 in Paris. 1931-32 teaches at Art Students League, New York. Joins WPA Federal Art Project, 1933; executes WPA murals. Active member of Artists' Congress, editor of Artists' Union magazine, *Art Front,* 1935-36. 1940-50 teaches at New School for Social Research, New York. Dies in New York.

> The Museum of Modern Art, New York, October 17, 1945-February 3, 1946, *Stuart Davis;* cat. text by James Johnson Sweeney
>
> E. C. Goossen, *Stuart Davis,* New York, 1959
>
> National Collection of Fine Arts, Washington, D.C., May 28-July 5, 1965, *Stuart Davis Memorial Exhibition*; cat. text by H. H. Arnason. Traveled to: Art Institute of Chicago, July 30-August 29, 1965; Whitney Museum of American Art, New York, September 14-October 17, 1965; Art Galleries, University of California at Los Angeles, October 31-November 28, 1965
>
> Diane Kelder, ed., *Stuart Davis,* New York, Washington, D.C., and London, 1971

Charles Demuth
1883-1935
Born in Lancaster, Pennsylvania. 1900-07 studies successively at Drexel Institute, School of Industrial Art, Pennsylvania Academy of Fine Arts with Anshutz, Chase and others, all in Philadelphia. 1904 first trip to Paris. 1907-08 several months in Paris, meets Matisse and other Fauves; trips to Berlin, London. 1908-11 at Pennsylvania Academy again. 1912-14 Paris, frequents Stein circle, associates with Marsden Hartley, Picasso, Duchamp, Delaunay, among others; intense interest

in Cézanne; studies at *Académies Moderne, Colarossi, Julian.* 1914 first of many one-man exhibitions at Daniel Gallery, New York. Upon return to United States divides his time between Lancaster and New York, summering in Provincetown. Attends Arensberg salon, visits Stieglitz's "291." Illustrates many books, including James' *Turn of the Screw,* 1918-19, *The Beast in the Jungle,* 1919-20. 1920-21 last trip to Europe, visits London and Paris. Dies in Lancaster.

A. E. Gallatin, *Charles Demuth,* New York, 1927

Charles Demuth, "Across a Greco is Written," *Creative Art,* vol. 5, no. 3, September 1929, pp. 629-634

Henry McBride, "Water Colors by Charles Demuth," *Creative Art,* vol. 5, no. 3, September 1929, pp. 634-635

The Museum of Modern Art, New York, March 7-June 11, 1950, *Charles Demuth;* cat. texts by Andrew Carnduff Ritchie and Marcel Duchamp. Traveled to: Detroit Institute of Fine Arts, October 1-29; University of Miami, Coral Gables, Florida, November 20-December 12; Winnipeg Art Gallery, Canada, December 28, 1950-January 18, 1951; Williams College, Williamstown, Massachusetts, February 3-24; University of Delaware, Newark, March 10-31; Oberlin College, Allen Memorial Art Museum, Ohio, April 14-May 5

The Art Galleries, University of California at Santa Barbara, October 5-November 14, 1971, *Charles Demuth, The Mechanical Encrusted on the Living*; cat. texts by David Gebard and Phyllis Plous. Traveled to: University Art Museum, University of California at Berkeley, November 22, 1971-January 3, 1972; The Phillips Collection, Washington, D.C., January 19-February 29; Munson-Williams-Proctor Institute, Utica, March 19-April 16

necticut. Through Maurer meets Stieglitz who includes him in group exhibition at "291," New York, 1910. 1912 first one-man exhibition comprised of 1911 pastels which may be earliest abstractions executed in America. In succeeding years shows most regularly at Anderson Galleries, Intimate Gallery and An American Place, New York. 1920's lives on Long Island, continues to work as illustrator, turns to collage. 1933-38 lives in Geneva. 1938 returns to Long Island, where he lives until his death.

Andrew Dickson White Museum of Art, Cornell University, Ithaca, New York, November 1954, *Arthur G. Dove, 1880-1946: A Retrospective Exhibition;* cat. text by Alan R. Solomon

Art Galleries of University of California at Los Angeles (organizer), *Arthur G. Dove;* cat. text by Frederick S. Wight. Traveled to: Whitney Museum of American Art, New York, October 1-November 16, 1958; Phillips Memorial Gallery, Washington, D.C., December 1, 1958-January 5, 1959; Museum of Fine Arts, Boston, January 25-February 28; Marion Koogler McNay Art Institute, San Antonio, March 18-April 18; Art Galleries of the University of California at Los Angeles, May 9-June 15; Art Center, La Jolla, June 20-July 30; San Francisco Museum of Art, August 15-September 30

Art Gallery, University of Maryland, College Park, March 13-April 19, 1967, *Arthur G. Dove, The Years of Collage*; cat. text by Dorothy Rylander Johnson

San Francisco Museum of Art, November 21, 1974-January 5, 1975, *Arthur Dove;* cat. text by Barbara Haskell. Traveled to: Albright-Knox Art Gallery, Buffalo, January 27-March 2; The St. Louis Art Museum, April 3-May 25; The Art Institute of Chicago, July 21-August 31; Des Moines Art Center, September 22-November 2; Whitney Museum of American Art, New York, November 24, 1975-January 18, 1976

Arthur G. Dove
1880-1946
Born in Canandaigua, New York. 1882 to Geneva, New York. Studies at Hobart College, Geneva, and Cornell University, Ithaca, 1899-1903. To New York, 1904, works as commercial illustrator. 1906 trip to Europe, paints in southern France, visits Italy; meets Alfred Maurer who becomes close friend. 1910 moves with family to Westport, Con-

Marcel Duchamp
1887-1968
Born in Blainville, near Rouen. Brother of Jacques Villon and Raymond Duchamp-Villon. To Paris, studies at *Académie Julian.* 1909 first exhibition, *Salon d'Automne,* Paris. 1911 begins cubistic works which emphasize successive images of body in motion. 1912 *Nude Descending a Stair-*

case; with Picabia and Apollinaire, development of radical Dada-like ideas antedating official founding of Dada movement in 1916. 1913 critical year in development of mature style: begins mechanical drawings; exhibits at Armory Show, New York. 1914 Readymades. 1915 leaves Paris for New York, becomes important member of Arensberg circle. 1916 founding member Society of Independent Artists. 1918 Buenos Aires. 1919-23 lives in Paris and New York. 1920 with Katherine S. Dreier and Man Ray in New York founds *Société Anonyme.* 1923 settles in Paris, visits New York occasionally until 1942. Association with Surrealists in Paris. 1942 returns to New York where he resides until his death. Associates with expatriate Surrealists in New York during war. 1955 becomes United States citizen. c. 1960 association with younger American artists including Johns, Rauschenberg, Oldenburg.

Robert Lebel, *Sur Marcel Duchamp,* Paris, 1959; English translation by George Heard Hamilton, *Marcel Duchamp,* New York, 1959

Arturo Schwarz, *The Complete Works of Marcel Duchamp,* New York, 1969; revised edition, 1970

The Philadelphia Museum of Art, September 22-December 9, 1973, *Marcel Duchamp;* cat. texts by davidantin, Richard Hamilton, Robert Lebel, Lucy R. Lippard, Kynaston McShine, Michel Sanouillet, Arturo Schwarz, Lawrence D. Steefel, Jr., John Tancock, poem by Octavio Paz. Traveled to: The Museum of Modern Art, New York, December 28, 1973-February 24, 1974; The Art Institute of Chicago, March 20-May 5

Arshile Gorky
1905-1948
Born Vosdanig Manoog Adoian, in Khorkom Vari, Hayotz Dzore, Turkish Armenia. 1916-18 studies at Polytechnic Institute, Tiflis, U.S.S.R. 1920 to United States, lives in Watertown, Massachusetts, then Providence, where he studies at Rhode Island School of Design. 1923 to Boston, studies at New School of Design, becomes instructor in life drawing there, 1924. 1925 moves to New York; enrolls at Grand Central School of Art, then teaches there until 1931; changes name to Arshile Gorky during this period. 1934 first one-man show, Mellon Galleries, Philadelphia. 1935 joins WPA Federal Art Project, for which he executes murals. 1938 first one-man exhibition in New York, Boyer Galleries. 1941 organizes camouflage course at Grand Central School of Art. 1942 first visit to Connecticut;

draws and paints in the country, either in Connecticut or Virginia, for part of each year until his death. 1945-48 exhibits annually at Julien Levy Gallery, New York. Dies by suicide in Sherman, Connecticut.

Ethel K. Schwabacher, *Arshile Gorky,* New York, 1957, pp. 96-97, 116-121

The Museum of Modern Art, New York, *Drawing by Arshile Gorky;* cat. text by Frank O'Hara. Circulated by The International Council in Europe, 1963-67

Julien Levy, *Arshile Gorky,* New York, 1966

Art Gallery, University of Maryland, College Park, March 20-April 27, 1969, *The Drawings of Arshile Gorky;* cat. text by Brooks Joyner

M. Knoedler & Co., Inc., New York, November 25-December 27, 1969, *Gorky: Drawings;* cat. text by Jim M. Jordan

Marsden Hartley
1877-1943
Born in Lewiston, Maine, of English parents. To Cleveland in late childhood. 1892 studies at Cleveland School of Art. To New York, 1898; studies at Art Students League under William Merritt Chase, 1898-99; at National Academy of Design, 1900-01. By 1908 paints in Impressionist style. First one-man exhibition, Stieglitz's "291," New York. Influenced by Cézannes and Picassos at "291." First trip to Europe 1912-13; beginning of assimilation of advanced European styles: brief experimentation with Cubism in Paris, more significantly affected by association with Kandinsky and Marc in Germany. Exhibited 1913 at Armory Show, New York, and *Herbstsalon,* Berlin. 1914-15 Berlin, abstract experiments continue. United States, December 1915-21. By 1920 art becomes increasingly representational. Lives in Europe, 1922-29, visiting United States, 1928. Abandons expressionism by 1928 for more severely disciplined style reflecting Cézanne's influence. Active as poet. Lives in United States, primarily in New York and New England, from 1930 until his death, visiting Mexico, 1932-33; Germany, 1933. Dies in Ellsworth, Maine.

Elizabeth McCausland, *Marsden Hartley,* Minneapolis, 1952

Gorham P. Munson, "Homage to Marsden Hartley," *Arts,* vol. 35, no. 5, February 1961, pp. 32-41

Hans Hofmann
1880-1966
Born in Weissenburg, Bavaria. To Munich, 1886. Early interest in science, mathematics, music. 1898 studies art with Willi Schwarz who introduces him to Impressionism. 1904-14 in Paris; studies at *Académie de la Grande Chaumière*; friendship with Delaunay who influences his development as a colorist. Knew Cubist group, painted in Cubist style. First one-man exhibition, Paul Cassirer, Berlin, 1910. 1914 returns to Munich, outbreak of war forces him to remain there. 1915 opens school in Munich. 1930 invited to teach at University of California, Berkeley. Settles permanently in America, 1932. Opens first school, New York, 1933; succeeded by Hans Hofmann School of Fine Arts, New York, 1934; begins conducting summer sessions in Provincetown, 1935, becoming one of most influential art teachers in United States. After long period devoted exclusively to drawing, returns to painting, 1935. 1941 becomes United States citizen. 1940's transition to abstraction. First one-man exhibition in New York at Peggy Guggenheim's Art of This Century, 1944. Late 1950's begins characteristic paintings in which rectangle functions as anchor. 1958 closes schools, paints full-time. Dies in New York.

Clement Greenberg, *Hofmann,* Paris, 1961

Hans Hofmann, *Hans Hofmann,* New York, 1963

Jasper Johns
b. 1930
Born in Augusta, Georgia. Grows up in South Carolina. Studies at University of South Carolina, Columbia. To New York briefly, 1949, returns after military service, 1952. Works as display artist for stores. 1954-55 first *Target, Flag, Number* paintings; these shown at first one-man exhibition, Leo Castelli Gallery, New York, 1958. Begins sculpture during this period, using flashlights, lightbulbs, beer cans as subject matter. Intensive and innovative work in printmaking since first lithographs in 1960. From 1963 Director of Foundation for Contemporary Performance Arts. Artistic advisor to Merce Cunningham. Collaboration with Cunningham includes ballet *Un Jour ou deux* with John Cage for Paris Opera, 1973. Lives in upstate New York and in St. Martin, French West Indies.

The Jewish Museum, New York, February 16-April 12, 1964, *Jasper Johns*; cat. text by Alan R. Solomon

Max Kozloff, *Jasper Johns,* New York, 1967, pp. 46-47

Arts Council of Great Britain, *Jasper Johns Drawings*; excerpts from interview of Johns by David Sylvester. Traveled to: Museum of Modern Art, Oxford, September 7-October 13, 1974; Mappin Art Gallery, Sheffield, October 19-November 17; Herbert Art Gallery, Coventry, November 30-December 29; Walker Art Gallery, Liverpool, January 4-February 2, 1975; City Art Gallery, Leeds, February 8-March 9; Serpentine Gallery, London, March 20-April 20

Ellsworth Kelly
b. 1923
Born in Newburgh, New York. Studies at Pratt Institute, New York, 1941-42. Military service in France and England in camouflage unit, 1943-45. 1946-48 studies drawing and painting at Boston Museum School, lives and teaches at Norfolk House Center, Roxbury, Massachusetts. 1948 to France, settles in Paris. Studies at *Ecole des Beaux-Arts,* Paris, 1948; studies Romanesque painting and architecture. First abstract paintings, 1949. 1950 first collages. 1950-51 teaches at American School, Paris. First one-man exhibition, Galerie Arnaud, Paris, 1951. Paints in south of France, 1951-52. Returns to New York, 1954. First one-man exhibition in New York, Betty Parsons Gallery, 1956. First sculpture executed for Transportation Building, Penn Center, Philadelphia, 1956. Mural commission for UNESCO, Paris, 1969. Extensive exhibitions in United States and abroad include show at Albright-Knox Art Gallery, Buffalo, 1972. Lives in Chatham, New York.

Diane Waldman, *Ellsworth Kelly: Drawings, Collages, Prints,* Greenwich, Conn., 1971

Diane Waldman, "Kelly, Collage and Color," *Art News,* vol. 70, no. 8, December 1971, pp. 44-46, 53-55

The Museum of Modern Art, New York, September 12-November 4, 1973, *Ellsworth Kelly.* E. C. Goossen, *Ellsworth Kelly,* Greenwich, Conn., 1973, published in conjunction with exhibition

Franz Kline
1910-1962
Born in Wilkes-Barre, Pennsylvania. Attends School of Fine and Applied Arts of Boston University, 1931-35; Heatherly's Art School, London, 1937-38. 1938 returns to New York where he lives

until his death. Works of the early 1940's primarily fairly realistic city-scapes; characteristic mature abstract, black and white style begins to appear by c. 1949. First one-man exhibition, Egan Gallery, New York, 1950. Teaches at Black Mountain College, Black Mountain, North Carolina, summer 1952; Pratt Institute, Brooklyn, 1953-54; Philadelphia Museum School of Art, 1954. Restricts palette for the most part to black and white in early 1950's, but reintroduces color in mid-decade. Recognized as major American artist shortly after first one-man show, which was followed by extensive national and international exhibitions and numerous prizes.

The Museum of Modern Art, New York, *Franz Kline.* Circulated by The International Council in Europe, 1963-64

Jules Langsner, "Franz Kline: Calligraphy and Information Theory," *Art International,* vol. 7, no. 3, March 25, 1963, pp. 25-29

Whitney Museum of American Art, New York, October 1-November 24, 1968, *Franz Kline: 1910-1962*; cat. text by John Gordon. Traveled to: Dallas Museum of Fine Arts, December 17, 1968-January 26, 1969; San Francisco Museum of Art, February 21-March 30; Museum of Contemporary Art, Chicago, April 12- May 25

Willem de Kooning
b. 1904
Born in Rotterdam. From 1916 apprenticed to painting and decorating firm; 1916-25 studies intermittently at Rotterdam Academy of Fine Arts and Techniques. After further study in Brussels and Antwerp, emigrates to United States, 1926. Lives in Hoboken, New Jersey, working as house painter; 1927 to New York, employed as commercial artist. Meets John Graham, Stuart Davis; also Arshile Gorky, with whom he shares a studio in late 1930's. 1935 becomes full-time painter; participates in WPA mural and easel painting project in New York, 1935-36. Works concurrently on abstractions and male figure paintings. 1938 first "woman" series; female figure becomes a major preoccupation, paralleled in 1940's by black and white abstractions. First one-man exhibition, Egan Gallery, New York, 1948. Teaches at Black Mountain College, Black Mountain, North Carolina, summer 1948. 1957 begins abstract urban landscapes. 1963 moves to Springs, New York, where he still lives and works. Begins "woman in landscape series," 1963. 1969 first sculpture cast; 1970-71 begins figurative life-size sculpture.

The Museum of Modern Art, New York, March 3-April 27, 1968, *Willem de Kooning.* Traveled to: Stedelijk Museum, Amsterdam, September 19-November 17; Tate Gallery, London, December 8, 1968-January 26, 1969; Art Institute of Chicago, May 16-July 6, Los Angeles County Museum, July 28-September 14

Thomas B. Hess, *Willem de Kooning Drawings,* Greenwich, Conn., 1972

Harold Rosenberg, *De Kooning,* New York, 1973

Walker Art Center, Minneapolis, March 10-April 21, 1974, *de Kooning drawings / sculptures*; cat. texts by Philip Larson and Peter Schjeldahl. Traveled to: The National Gallery of Canada, Ottawa, June 7-July 21; The Phillips Collection, Washington, D.C., September 14- October 27; Albright-Knox Art Gallery, Buffalo, December 3, 1974-January 19, 1975; The Museum of Fine Arts, Houston, February 21-April 6

Roy Lichtenstein
b. 1923
Born in New York. Studies under Reginald Marsh at Art Students League, New York, 1939; 1940-43 Ohio State University, Columbus; after military service, 1943-46, returns to Ohio State for BFA, 1946; MFA, 1949. 1949-51 teaches at Ohio State University; 1951-57 lives in Cleveland, painting and supporting self at odd jobs. First one-man exhibition, Carlebach Gallery, New York, 1951. Teaches at State University of New York, Oswego, 1957-60; Douglas College, Rutgers University, New Brunswick, New Jersey, 1960-63. After painting American scenes, then in form of Abstract Expressionism, by 1961 portrays comic strip themes and isolated objects of common origin. Later expands repertory to parodies of masters such as Cézanne, Abstract Expressionist brushstrokes, and since 1966 decorative style of 1930's, executed in primary colors, Ben Day dots, mechanical line. Begins sculpture 1967. Uses plastics, enamels, silkscreen, ceramics. 1963-70 lives in New York; now resides in Southampton, New York.

The Solomon R. Guggenheim Museum, New York, September 19-November 9, 1969, *Roy Lichtenstein*; cat. text by Diane Waldman

Diane Waldman, *Roy Lichtenstein,* New York, 1971

Centre National d'Art Contemporain, Paris, January 7-February 17, 1975, *Roy Lichtenstein: Dessin sans band*; cat. text by Daniel Abadie

Stanton Macdonald-Wright
1890-1973
Born in Charlottesville, Virginia. 1904-05 studies at Art Students League, Los Angeles. 1907 to Paris; studies at *Sorbonne, Académies Julian, Colarossi, Ecole des Beaux Arts.* Meets Morgan Russell. They read color theories of Chevreul, Rood, Blanc, Helmholtz; study their application with Tudor-Hart. Together devise Synchromy, emphasizing color in reaction to monochromatic Cubism. First Synchromist exhibition at *Neue Kunstsalon,* Munich, 1913; Synchromism shown first in United States, 1914, Carroll Gallery, New York. 1916-18 lives in New York. 1919 produces first full-length stop motion color film. Develops color process for movies. 1920 interest in Oriental philosophies; 1924 returns to representation, influenced by Chinese painting. Active as teacher and writer. From 1954 both non-objective and figurative work. Repeated visits to Orient. Lives in California and Tokyo. Dies in Pacific Palisades, California.

> National Collection of Fine Arts, Washington, D.C., May 4-June 18, 1967, *The Art of Stanton Macdonald-Wright;* Contains selections of writings by the artist
>
> "The Artist Speaks: Stanton Macdonald-Wright," *Art in America,* New York, vol. LV, no. 3, May-June 1967, pp. 70-73. Note by Barbara Rose, statement by the artist
>
> Henry M. Reed, *Synchromism and Related Tendencies in American Abstract Painting,* chapter III, unpublished manuscript

Robert Motherwell
b. 1915
Born in Aberdeen, Washington. To San Francisco, 1918. Studies at Stanford University, Palo Alto, majoring in philosophy, 1932-36. 1935 first of many visits to Europe. Graduate work in philosophy, Harvard University, Cambridge, 1937-38; Université de Grenoble, France, 1938; graduate studies in art history, Columbia University, New York, 1940-41, with Meyer Schapiro who encourages him to paint. 1940's association with European artists in exile in New York, particularly Surrealists; intense interest in automatism. 1941 decides to devote self to painting. Collage be-

comes a major interest, 1943. First one-man exhibition, Peggy Guggenheim's Art of This Century, New York, 1944. 1948 founding member "Subjects of the Artists" school, New York. Active as writer and editor of magazines and art books. Extensive teaching includes Black Mountain College, Black Mountain, North Carolina, summers 1945, 51; Hunter College, New York, 1951-58, 1971-72. Resides in Greenwich, Connecticut, where he moves in 1971, after living many years in New York, and summers in Provincetown.

> Bennington College, Bennington, Vermont, April 24-May 23, 1959, *Motherwell: First Retrospective Exhibition*
>
> Galerie Berggruen, Paris, August 1961, *Robert Motherwell: Collages, 1958-1960*; cat. text by Sam Hunter
>
> The Museum of Modern Art, New York, October 1-November 28, 1965, *Robert Motherwell: With Excerpts from the Artist's Writings;* cat. text by Frank O'Hara. Circulated by The International Council in Europe, 1966
>
> The Museum of Modern Art, New York, *Robert Motherwell: Works on Paper*; cat. text by H. H. Arnason. Circulated by The International Council in South America, 1967-68
>
> Galerie im Erker, St. Gallen, June 12-August 28, 1971, *Robert Motherwell: Bilder und Collagen 1967-1970*; cat. texts by Octavio Paz and Bryan Robertson
>
> The Museum of Fine Arts, Houston, November 15, 1972-January 14, 1973, *The Collages of Robert Motherwell: A Retrospective Exhibition*; cat. text by E. A. Carmen, Jr. Traveled to: Cleveland Museum of Art, February 6-25; Wadsworth Atheneum, Hartford, March 14-April 22; Museum of Fine Arts, Boston, May 10-June 24
>
> The Art Museum, Princeton University, New Jersey, January 5-February 17, 1973, *Robert Motherwell: Recent Work*; cat. texts by Sam Hunter, Harry B. Titus, Peter S. Rohowsky, Deborah P. Strom, interview by Irmeline Lebeer, translated from *Chroniques de l'art vivant,* no. 22, July-August 1971

Barnett Newman
1905-1970
Born in New York. Studies at Art Students League, New York, with Duncan Smith, John Sloan, William von Schlegel; City College, New York, 1923-27,

receives BA; graduate work, Cornell University, Ithaca, New York, 1941. Abandons painting, 1939-44, returns to it thereafter. First paintings of vertical elements, 1946. Associate editor for two issues of *Tiger's Eye,* 1947. Member of "Subjects of the Artists" school, New York, 1948. First sculpture, 1950; first one-man exhibition, Betty Parsons Gallery, New York, 1950. Retrospective, Bennington College, Bennington, Vermont, 1958. Leader of Artists Workshop, University of Saskatchewan, Saskatoon, Canada, 1959; conducts graduate seminars, University of Pennsylvania, Philadelphia, 1962-63. Dies in New York.

> Thomas B. Hess, *Barnett Newman,* New York, 1969
>
> The Museum of Modern Art, New York, October 21, 1971-January 10, 1972, *Barnett Newman*; cat. text by Thomas B. Hess. Traveled to: Tate Gallery, London, June 28-August 6

Georgia O'Keeffe
b. 1887
Born near Sun Prairie, Wisconsin. 1902 moves to Williamsburg, Virginia. Studies with John Vanderpoel at Art Institute of Chicago, 1905-06; Art Students League, New York, under William Merrit Chase, F. Luis Mora, Kenyon Cox, 1907-08. Abandons painting for commercial art in Chicago, 1908-12. Begins painting again, 1912, teaches art in Texas. 1914-16 studies art with Arthur Dow at Teachers College, Columbia University, New York; continues to paint and teach at various schools in South and West. 1916 participates in first group exhibition, Stieglitz's "291," New York. First one-woman show, "291," 1917. 1918-28 New York and Lake George, often summering in Maine. 1924 marries Stieglitz. Exhibits regularly at Anderson Galleries, then Intimate Gallery, then An American Place, New York, 1923-49. From 1929 summers in New Mexico; 1932 Gaspé Peninsula; 1934 Bermuda; 1938 Hawaii. Death of Stieglitz, 1946. Since 1949 has lived in Abiquiu, New Mexico. Has traveled in Mexico, Europe, Peru, Near and Far East.

> Worcester Art Museum, Massachusetts, October 4-December 4, 1960, *An Exhibition by Georgia O'Keeffe*; cat. text by Daniel Catton Rich
>
> Amon Carter Museum of Western Art, Fort Worth, March 17-May 8, 1966, *Georgia O'Keeffe: An Exhibition of the Works of the Artist from 1915-1966*; cat. edited by Mitchell Wilder

Whitney Museum of American Art, New York, October 8-November 29, 1970, *Georgia O'Keeffe*; cat. text by Lloyd Goodrich. Traveled to: Art Institute of Chicago, January 6-February 7, 1971; San Francisco Museum of Art, March 15-April 30

Claes Oldenburg
b. 1929
Born in Stockholm. 1930-31 lives in New York and Rye; 1933-37 Oslo; 1937-56 Chicago. 1946-50 studies at Yale University, New Haven; 1952-54 Art Institute of Chicago with Paul Wieghardt. To New York, 1956. First one-man exhibitions, 1959, Cooper Union Art School Library, New York (drawings), Judson Gallery, New York (constructions). First Happenings, 1960. *The Store,* total environment in which all objects are made by the artist but displayed in actual store in New York, opens 1961. "Ray Gun Theater," ten theater pieces presented at *The Store,* 1962. First soft sculpture, 1962. 1963-64 to Venice, California. 1964 returns to New York. 1965 begins multiple editions of sculpture. Works with Gemini printmakers, Los Angeles, 1968. First "feasible" monument, *Lipstick (Ascending) on Caterpillar Tracks,* realized at Yale University, 1969. Now working on monumental outdoor sculpture. Lives in New York.

> Moderna Museet, Stockholm, September 17-October 30, 1966, *Claes Oldenburg Skulpturer och Tecknigar.* Cat. texts by Oyvind Fahlström and Ulf Linde (in Swedish), statements by the artist (in Swedish and English)
>
> The Museum of Modern Art, New York, September 23-November 23, 1969, *Claes Oldenburg*; cat. text by Barbara Rose
>
> Gene Baro, *Claes Oldenburg: Drawings and Prints,* London and New York, 1969
>
> Claes Oldenburg, *Proposals for Monuments and Buildings, 1965-69,* Chicago, 1969
>
> Claes Oldenburg, "Chronology of drawings," *Studio International,* print supplement, vol. 179, no. 923, June 1970, pp. 249-253
>
> Kunsthalle Tübingen, March 1-April 4, 1975, *Zeichnungen von Claes Oldenburg*; cat. texts by Götz Adriani, Dieter Koepplin and Barbara Rose. Traveled to: Kunstmuseum Basel, May 10-July 6; Städtische Galerie im Lenbachhaus, Munich, July 17-August 31; National-

galerie Berlin Staatliche Museen Preussischer Kulturbesitz, September 17-October 26; Kaiser Wilhelm Museum, Krefeld, November 14, 1975-January 4, 1976; Museum des 20. Jahrhunderts, Vienna, January 14-February 29; Kunstverein Hamburg, April- May; Städtische Galerie im Städelschen Kunstinstitut Frankfurt am Main, June-July; Kestner-Gesellschaft Hannover, September-October; Louisiana Museum Humlebaek, Denmark, November-December

Jackson Pollock
1912-1956
Born in Cody, Wyoming. Grows up primarily in Arizona and California. Studies painting at Manual Arts High School, Los Angeles. 1930 to New York, studies with Thomas Hart Benton at Art Students League. After trips to West, settles permanently in New York, 1935. 1938-42 works on Federal Art Project. First one-man exhibition, Peggy Guggenheim's Art of This Century, New York, 1943. 1943-47 contract from Peggy Guggenheim allows him to paint full-time. Contract with Betty Parsons follows. 1946 moves to Springs, New York, where he lives until his death. Before 1947 painted in Surrealist idiom using mythical or totemic figures. 1947 first paintings in mature style employing drip technique. Early 1950's series of more austere and sparse paintings limited to black and white; from c. 1950 figurative works parallel abstractions. Dies in automobile accident.

> Frank O'Hara, *Jackson Pollock,* New York, 1959
>
> Bryan Robertson, *Jackson Pollock,* New York, 1960
>
> William Rubin, *Jackson Pollock and the Modern Tradition,* New York, 1967
>
> The Museum of Modern Art, New York (organizer), *Jackson Pollock: Works on Paper.* Bernice Rose, *Jackson Pollock: Works on Paper,* Greenwich, Conn., 1969, published in conjunction with exhibition. Traveled in part to: Walker Art Center, Minneapolis, February 11-March 10, 1968; Art Gallery, University of Maryland, College Park, April 1-22; Museum of Contemporary Art, Chicago, May 24-June 29; Seattle Art Museum, July 11-August 18; The Baltimore Museum of Art, September 8-October 6; Montreal Museum of Fine Arts, October 21-November 18; Portland Art Museum, December 2, 1968-January 1, 1969; Rose Art Museum, Brandeis University, Waltham, Massachusetts, January 20-February 16
>
> The Museum of Modern Art, New York, April 5-June 4, 1967, *Jackson Pollock;* cat. text by Francis V. O'Connor
>
> C. L. Wysuph, *Jackson Pollock: Psychoanalytic Drawings,* New York, 1970

Man Ray
b. 1870
Born in Port Arthur, Texas. Studies at Kansas City for architectural drafting firm. Part-time studies at National Academy of Design, Art Students League, New York; after 1912 life drawing classes at Ferrer Center, New York, under Henri and Bellows. Frequents Stieglitz's "291," visits Armory Show, New York, 1913, is drawn to advanced European art he sees there. 1913 forms with other artists and writers a small community near Ridgefield, New Jersey, where he lives until 1915, when he returns to New York. First one-man exhibition, Daniel Gallery, New York, 1915. Meets Duchamp, forms life-long friendship. Duchamp encourages his experiments with various media which absorb him in succeeding years, including photography (photographs and rayographs), films, airbrush painting (aerographs), collage and sculpture in mixed media. 1921 settles in Paris. Associates with Parisian Dadaists and Surrealists, participates in their activities and exhibitions. 1940-51 lives in Hollywood. 1951 returns to Paris where he still lives.

> Valentine Gallery, New York, 1936, *Drawings by Man Ray;* cat. text by Paul Eluard
>
> Musée National d'Art Moderne, Paris, January 7-February 28, 1972, *Man Ray;* cat. text by Alain Jouffroy, selections from writings by the artist
>
> The New York Cultural Center, New York, December 19, 1974-February 16, 1975, *Man Ray: Inventor / Painter / Poet;* cat. texts by William Copley, Janus (translated and edited by Mario Amaya). Traveled to Institute of Contemporary Arts, London, April 11-June 1
>
> Roland Penrose, *Man Ray,* London and Boston, 1975

Robert Rauschenberg
b. 1925
Born in Port Arthur, Texas. Studies at Kansas City Art Institute, 1946-47; *Académie Julian,* Paris, 1947; Black Mountain College, Black Mountain,

North Carolina, with Albers, where he learns photography, music, modern dance, as well as painting, 1948-49; Art Students League, New York, 1949-50. First one-man exhibition, Betty Parsons Gallery, New York, 1951. 1951-52 travels in Italy, Morocco. 1952 returns to New York, begins theater work with Merce Cunningham, Paul Taylor. From 1955 association with John Cage, Jasper Johns who encourage him. Unconventional materials, innovative combinations of various media mark work throughout career: including all black and all white paintings, rope objects and boxes; combines—objects juxtaposed with painterly passages—, screen painting, theater pieces, floor pieces, sculpture with sound. 1961 intensive work with lithographs which influence his painting. Collaborative efforts with other artists. 1966 co-founder of organization EAT (Experiments in Art and Technology). Lives and works in New York and Captiva, island off Florida.

The Jewish Museum, New York, March 31-May 12, 1963, *Robert Rauschenberg*; cat. text by Alan R. Solomon

The Museum of Modern Art, New York, December 21, 1965-March 20, 1966, *Rauschenberg: 34 Drawings for "Dante's Inferno;"* cat. text by William S. Lieberman. Circulated by The International Council in the United States and Europe, 1964-69

Andrew Forge, *Rauschenberg,* New York, 1969

Mark Rothko
1903-1970

Born in Dvinsk, Russia. 1913 to Portland, Oregon. Studies liberal arts, Yale University, New Haven, 1921-23. Settles in New York, 1925. Briefly studies under Max Weber at Art Students League, New York, 1925. 1933 first one-man exhibition, Contemporary Arts Gallery, New York. 1935 founding-member "The Ten," group of expressionist-oriented artists. Works on WPA Federal Art Project, New York, 1936-37. 1945 one-man show, Peggy Guggenheim's Art of This Century, New York, of mythic, Surrealist work. Founding member "Subjects of the Artist" school, New York, 1948. Teaches at California School of Fine Arts, San Francisco, summer 1947, 49; Brooklyn College, 1951-55; University of Colorado, Boulder, 1955; Tulane University, New Orleans, 1956. Characteristic mature abstract style of dematerialized rectangles of color formulated by late 1949-50. Extensive exhibitions include participation in XXIV

Venice Biennale, 1958; major retrospective The Museum of Modern Art, New York, 1961. Death by suicide in New York. Dedication of Rothko Chapel, Institute for Religion and Human Development, Houston, 1971.

Robert Goldwater, "Reflections on the Rothko Exhibit," *Arts,* New York, vol. 35, no. 6, March 1961, pp. 42-45

Kunsthaus Zürich, 1971, *Mark Rothko;* cat. texts by Werner Haftmann, Donald McKinney, and the artist. Traveled to: Städtische Kunsthalle, Dusseldorf, August 24-October 3; Paris, Musée National d'Art Moderne, March 23-May 8, 1972

Morgan Russell
1886-1953

Born in New York. Early architectural studies. To Paris, Italy, 1906. Studies at Art Students League, New York, under Robert Henri and sculptor James Earle Fraser, 1906-09, while spending spring and summer in Paris. By mid-1908 frequents salon of Leo and Gertrude Stein, becomes aware of current French art, meets Matisse, Picasso, among others. 1909 settles in Paris; 1909-10 works with Matisse on sculpture series. 1910 returns to painting, deeply influenced by Cézanne. Late 1911 meets Stanton Macdonald-Wright, with whom he develops Synchromism in which pure color and light are explored. Synchromism first shown at *Neue Kunstsalon,* Munich, and Galerie Bernheim Jeune, Paris, 1913; in United States at Carroll Gallery, New York, 1914. Lives in south of France; returns to figuration, 1916. From 1920 involvement with metaphysics leads him to take up abstract Synchromies again. Dies in Broomall, Pennsylvania.

Rose Fried Gallery, New York, October 26-November 30, 1953, *An Exhibition in Memoriam: Morgan Russell (1886-1953)*; pamphlet text by Holger Cahill and statement by the artist translated from 1913 Galerie Bernheim Jeune, Paris, exhibition catalogue

M. Knoedler & Co., Inc., New York, October 12-November 6, 1965, *Synchromism and Color Principles in American Painting 1910-1930*; cat. text by William C. Agee

Henry M. Reed, *Synchromism and Related Tendencies in American Abstract Painting,* chapter III, unpublished manuscript

Frank Stella

b. 1936

Born in Malden, Massachusetts. 1950-54 studies at Phillips Academy, Andover, Massachusetts, with Hollis Frampton and Carl Andre; 1954-58 at Princeton, studies in William Seitz's open painting studio and with Stephen Greene. Early work influenced by Abstract Expressionism and Jasper Johns. To New York, 1958. Personal style emerges with *Black Series,* 1958. 1960 first shaped canvases; included in *16 Americans,* The Museum of Modern Art, New York; first one-man exhibition, Leo Castelli Gallery, New York. 1961 first trip to Europe. To Los Angeles, South America, 1965. Designs costumes and sets for Merce Cunningham's *Scramble,* 1967. Lives in New York.

> Robert Rosenblum, "Frank Stella, Five Years of Variations on an Irreducible Theme," *Artforum,* vol. III, no. 6, March 1965, pp. 21-25
>
> Pasadena Art Museum, October 18-November 20, 1966; *Frank Stella: An Exhibition of Recent Paintings*; cat. text by Michael Fried (reprinted as "Shape as Form: Frank Stella's New Painting," *Artforum,* vol. V, no. 3, November 1966, pp. 18-27, and in Henry Geldzahler, *New York Painting and Sculpture 1940-70,* New York, c. 1969, pp. 403-425)
>
> The Museum of Modern Art, New York, March 24-May 31, 1970, *Frank Stella*; cat. text by William S. Rubin. Traveled to: Pasadena Art Museum, January 8-February 28, 1971; Art Gallery of Ontario, Toronto, April 9-May 9

Joseph Stella

1877-1946

Born in Muro Locano, near Naples. 1896 to New York. Studies medicine and pharmacology, 1896-97. 1897 studies at Art Students League, New York; 1898-1900, New York School of Art. American themes—immigrants, urban scenes, miners—mark early work. Works as illustrator for popular magazines. 1909-12 returns to Europe, first stays in Italy, then Paris, where he meets Matisse, Modigliani, Carrà, probably Boccioni and Severini. Returns to New York, begins Futurist work. Exhibits in Armory Show, New York, 1913. 1915 associates with Arensberg circle. Draws upon New York environment, notably Brooklyn Bridge, for subject matter. 1920 joins *Société Anonyme,* participates in their exhibitions. Advanced use of collage begins in early 1920's. Becomes United States citizen, 1923. From 1920's until his death in New York, divides his time between Europe and New York.

> Rabin and Krueger Gallery, Newark, 1962, *Drawings of Joseph Stella from the Collection of Rabin and Krueger*; cat. text by William H. Gerdts
>
> Whitney Museum of American Art, New York, October 23-December 8, 1963, *Joseph Stella*; cat. text by John I. H. Baur
>
> Irma B. Jaffe, *Joseph Stella,* Cambridge, Mass., 1970; selected writings by the artist (in Italian)
>
> John I. H. Baur, *Joseph Stella,* New York, 1971

Clyfford Still

b. 1904

Born in Grandin, North Dakota. Grows up in Spokane, Washington, and Bow Island, Alberta. 1924 first visit to New York. Studies at Spokane University, BA, 1933. Teaches at Washington State University, Pullman, 1933. Fellow at Trask Foundation, Saratoga Springs, New York, summers 1934, 35. 1935 MA from Washington State University, where he teaches, 1935-41. 1943-45 teaches at Richmond Professional Institute, Virginia. First one-man exhibition, San Francisco Museum of Art, 1943. To New York, 1945. Shows at Peggy Guggenheim's Art of This Century, New York, 1946. 1946-50 teaches at California School of Fine Arts, San Francisco, which becomes extremely influential under his guidance. 1948 founding member "Subjects of the Artists" school, New York, from which he later withdraws. 1950-61 lives in New York. Major retrospective, Albright-Knox Art Gallery, Buffalo, 1959. Since 1961 has lived and worked in seclusion near Westminster, Maryland, exhibiting only rarely.

> Marlborough-Gerson Gallery, Inc., New York, November 26-January 3, 1969, *Clyfford Still Exhibition*

Cy Twombly

b. 1929

Born in Lexington, Virginia. Studies at Washington and Lee University, Lexington; Boston Museum School; Art Students League, New York; Black Mountain College, Black Mountain, North Carolina, 1951. 1951-53 lives in Spain, North Africa, Italy. First one-man exhibition, Kootz Gallery, New York, 1951. 1952-54 constructions with found objects; abstract paintings in impasto with incised lines. By mid-1950's abstract style of meandering, all-over linearism emerges. 1957 settles in Rome, where he still lives. Numerous exhibitions both in Europe and United States.

Heiner Bastian, *Cy Twombly: Zeichnungen 1953-1973,* Berlin, 1973

Kunstmuseum, Basel, May 5-June 24, 1973, *Cy Twombly: Zeichnungen 1953-1973*; cat. texts by Heiner Bastian and Franz Meyer

Institute of Contemporary Art, Philadelphia, March 15-April 27, 1975, *Cy Twombly: Paintings, Drawings, Constructions 1951-1974*; cat. text by Suzanne Delahanty. Traveled to: San Francisco Museum of Art, May 9-June 22, 1975

Andy Warhol
b. 1928
Born in Pittsburgh. 1945-49 studies pictorial design at Carnegie Institute of Technology (now Carnegie-Mellon University). 1949 to New York. Works in commercial design; first commercial work published in *Glamour* magazine. First one-man exhibition, Hugo Gallery, New York, 1952. 1956 travels in Europe and Far East. 1960 first paintings: imagery openly derived from comic strips and advertisements; such works first shown in one-man exhibition at Ferus Gallery, Los Angeles, 1962. Begins making underground films in his New York studio, The Factory, 1963; concentrates on film, 1964-early 70's when he begins to paint again. Preoccupation with repetition, boredom and morbid images. Major innovator in films, mixed-media fusions of music, film and dance, as well as in graphic art. Lives in New York.

Rainer Crone, *Andy Warhol,* New York, 1970

Pasadena Art Museum, May 12-June 21, 1970, *Andy Warhol.* John Coplans, *Andy Warhol,* Greenwich, Conn., 1970, with contributions by Jonas Mekas and Calvin Tompkins, published in conjunction with exhibition. Traveled to: Museum of Contemporary Art, Chicago, July 4-September 6; Stedelijk van Abbemuseum, Eindhoven, October 9-November 22; Musée d'Art Moderne de la Ville de Paris, December 10, 1971-January 23, 1972; Tate Gallery, London, February 17-March 28; Whitney Museum of American Art, New York, May 1-June 20, 1972

Joseph Masheck, "Warhol as illustrator: Early manipulations of the mundane," *Art in America,* vol. 59, no. 3, June 1971, pp. 54-59

Photographic Credits

Exhibition 76/1

4,000 copies of this catalogue, designed by Malcolm Grear Designers, typeset by Dumar Typesetting, Inc., have been printed by A. Colish, Inc., in January 1976 for the Trustees of The Solomon R. Guggenheim Foundation.